IMAGES
of America

NASHVILLE MUSIC
BEFORE COUNTRY

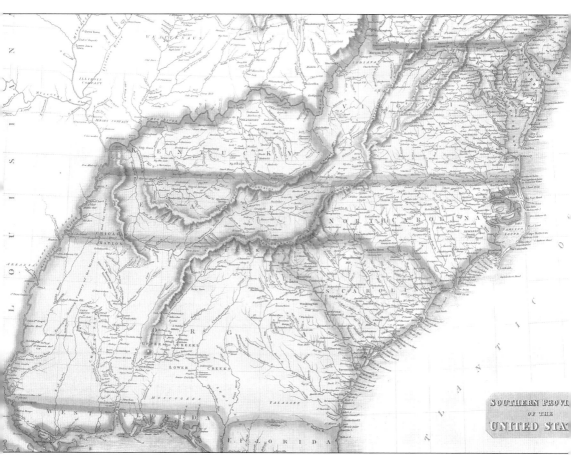

Tennessee appears on this 1817 map of the Southern Provinces of the United States. Tennessee, spelled "Tenasee" (a spelling closer to the Cherokee capital "Tanasi," for which the state was named), was originally the western extension of North Carolina until it became a state in 1796. (Library of Congress.)

ON THE COVER: The cultural centerpiece of the late 19th century Nashville home was the parlor piano. Nashville composers and publishers were an ever-renewable source for sheet music, and Nashville institutes trained young women to be pianists. For less than $200, a variety of Nashville piano merchants could supply the piano. (Center for Popular Music, Middle Tennessee State University.)

IMAGES
of America

NASHVILLE MUSIC
BEFORE COUNTRY

Tim Sharp

ARCADIA
PUBLISHING

Published by Arcadia Publishing
Charleston SC, Chicago IL, Portsmouth NH, San Francisco CA

Printed in the United States of America

Library of Congress Catalog Card Number: 2007943602

For all general information contact Arcadia Publishing at:
Telephone 843-853-2070
Fax 843-853-0044
E-mail sales@arcadiapublishing.com
For customer service and orders:
Toll-Free 1-888-313-2665

Visit us on the Internet at www.arcadiapublishing.com

Geographical regions may be the single greatest contributing factor to the music that has come from Tennessee. This book is dedicated to those regions defined as Southern Appalachia, the Cumberland River Valley, and the Mississippi Delta. It was in the Southern Appalachian area of West Virginia, Virginia, and East Tennessee that I learned to play banjo and discovered the music called bluegrass. It was in the Cumberland River Valley of Kentucky and Middle Tennessee that I completed much of my formal education and learned to appreciate the songwriters and craft of country music, as well as the business of music. It was in the Mississippi Delta area of West Tennessee that I embraced the blues and learned to celebrate the diversity of peoples that make this rich music possible.

CONTENTS

ACKNOWLEDGMENTS

Images used are courtesy of the Center for Popular Music, Middle Tennessee State University, Murfreesboro, Tennessee (CPM); Tennessee State Library and Archives, Nashville, Tennessee (TSL); Special Collection Division/Nashville Room, Nashville Public Library, Nashville, Tennessee (NPL); Memphis and Shelby County Room, Memphis Public Library, Memphis, Tennessee (MPL); Library of Congress, Washington, D.C. (LOC); Mississippi Valley Collection, The University of Memphis, Memphis, Tennessee (UOM); Special Collections Room, Belmont University (BU); the private hymnal collection of Dr. Richard Shadinger (RS); sketches used are from F. D. Srygley's 1891 publication *Seventy Years in Dixie* (FDS); and from the 1850s notebook of William A. Eichbaum (WAE). Unless otherwise attributed, additional images are courtesy of the author's collection.

Gratitude is expressed to Grover Baker, Mark Brown, Wayne Dowdy, Ed Frank, Susan L. Gordon, Marci Hendrix, Rebecca Horowitz, Patricia LaPointe, Karina McDaniel, Elizabeth Odle, Richard Shadinger, W. D. Sharp, the Mike Curb Institute of Music at Rhodes College, and to Jane and Emma for their support and patience.

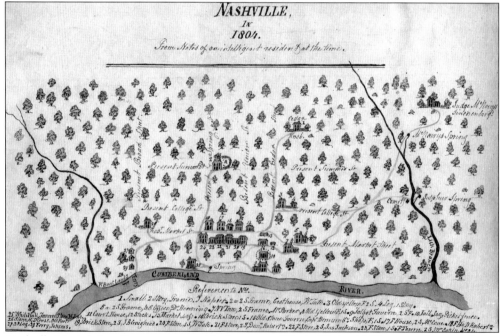

Nashville Music before Country starts with the story of Nashville itself. That story began when a flotilla of approximately 30 flatboats led by Col. John Donelson traveled more than 1,000 miles from Fort Patrick Henry in East Tennessee along the Holston, Tennessee, Ohio, and Cumberland Rivers to Fort Nashborough. (NPL.)

INTRODUCTION

For a Tennessean listening to the performance of folk music in Ireland, Northern Ireland, Scotland, or England, it only takes a squint of the eye and ear, and perhaps the absence of the smell of burning peat to feel the presence of something intrinsic and familiar. The Celtic fiddle, guitar, string bass, and occasional flute and hand percussion give constant hints as to the pedigree of the music native to rural Tennessee. As ballads and stories are told through song, a listener from Nashville, Chattanooga, Bristol, Knoxville, Jackson, or Memphis experiences something of a cultural déjà vu—the impression of familiarity.

The ballad and song tradition that migrated with early Irish, Scotch-Irish, Welsh, and English settlers into Tennessee was as natural as the transposition of their verbal languages and customs. The thousands of songs that flooded into the valleys of the Cumberland and Tennessee Rivers came from the lips of generations of folk performers of Southern Appalachia.

The songs and ballads of the Irish, Scotch-Irish, Welsh, and English immediately found their way into the culture and ways of the American South. Ballads were sung by folk singers in the hill country about King William of Orange, or as he was called by Irish Unionists, "King Billy." These hill-country balladeers singing about King Billy came to be known as the Billy-boys of the hills, or in short, "hill-billys." In the past, it was not uncommon to hear the music of the rural South called "hillbilly music."

Folk music and dance went hand in hand in Ireland, Scotland, Wales, and England with the fiddle serving as the anchor for this alliance. The dance known as the gigue, or "jig," the hornpipe, and the reel were deeply rooted in the tradition of the British Isles. Writer Billy Kennedy comments that "it seems likely that the greatest and most lasting contribution of the Scotch-Irish was music."

At first, cultural isolation kept music contained in the hills or in wilderness settings. But over time, population patterns caused a convergence of the various pods of population and cultures. Religion took a powerful hold on the settlers, and in 1801, great revivals became popular in rural Tennessee. These rural gatherings resulted in a body of wilderness spirituals and folk hymns. As the population grew, secular entertainment arrived and mingled with these songs in the form of minstrelsy. Religious songs and ballads in the mid-19th century were modeled after songs of minstrel songwriters.

In the early decades of the 19th century, trained musicians with European roots came to Nashville to establish themselves in the growing number of academies. By 1827, Nashville was home to a group of professional immigrant musicians, particularly Germans, and the city witnessed several flourishing music stores that supported the growth in interest of musical instruction. Starting in the 1820s, music instruction developed at a fast pace in Nashville.

At mid-century, Nashville supported new religious denominations and publishing houses. These were so well established by the time of the Civil War that the Union army was able to use the Southern Methodist Publishing House for their publishing needs. Print-music publishing soon included folk songs, minstrel songs, Civil War songs, gospel songs, hymnals, and spirituals published by various firms.

As Nashville grew, so did its number of educational institutions. These included the University of Nashville, Fisk University, Meharry Medical School, Nashville College for Young Ladies, Ward Seminary for Young Ladies, Vanderbilt University, St. Cecilia Academy, St. Bernard's

Academy, George Peabody College for Teachers, Watkins Institute, and Belmont Collegiate and Preparatory School.

Industry, transportation, education, distribution, religious enterprise, entertainment, and publishing had converged in Nashville by the beginning of the 20th century. The Union Gospel Tabernacle was completed in 1892 as a result of the work of Rev. Sam Jones and steamboat captain Tom Ryman. The building would later be renamed Ryman Auditorium and would play host to New York's Metropolitan Opera.

In 1901, Cornelius Craig and four other families established the National Life and Accident Insurance Company in Nashville, and in 1902, the city established the second oldest musician's union in the country. In 1925, the National Life and Accident Insurance Company put radio station WSM on the air as a new advertising and public relations experiment. Later that year, WSM broadcast the first, live, Saturday night musical show in Ryman Auditorium, launching the Grand Ole Opry. The convergence of the rural music of Tennessee with the business, educational, religious, entertainment, and publishing enterprise of Nashville brought to full bloom the story of *Nashville Music before Country*.

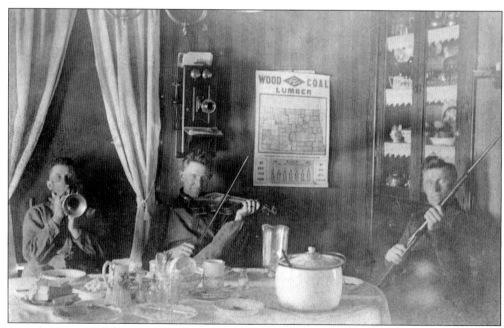

As early 17th and 18th century settlers came to the New World, they made accommodations in the areas of Virginia, North Carolina, and Tennessee for new sources of food, variations in geography, and different types of climate. Adaptations were not limited to physical survival and sustenance, but also included new subjects and circumstances for preexisting ballads and stories. (CPM.)

One

THE "ISLE" OF TENNESSEE

Variations on preexisting song themes were created as new influences and cultures on traditional musical material converged in Tennessee. New tools for working and playing were created or incorporated into the musical ensemble. While the Irish fiddle was an old friend, the African banjo was a new accommodation. New instrumental combinations also formed as the Irish fiddle, the Italian mandolin, the European guitar, and the African banjo met one another in fresh ensemble combinations.

Immigrants also brought their values, stories, lingering fights and feuds, prejudices, and political arguments and attitudes. This cultural baggage informed and influenced the early settlements in every way. Cultural isolation kept some of it in check for a while, but over time, population patterns ultimately led to a convergence of these various cultures with one another and with native as well as diverse immigrant influences.

What did not change was what early-20th-century British folk song collector Cecil J. Sharp identified in the preface to his collection *American-English Folk-Ballads*, which was "the true, sincere, ideal expression of human feeling and imagination." The music from all of the converging cultures held this expression in common. Early settlers carried with them the need to sing and express their feelings of despair and hope, as well as their Old World memories and New World desires.

SCHIRMER'S
AMERICAN FOLK-SONG SERIES

SET 22

AMERICAN-ENGLISH
FOLK-BALLADS

from the
Southern Appalachian Mountains

Collected and Arranged
with piano accompaniment

by

CECIL J. SHARP

Price, $1.25
[In U. S. A.]

The thousands of songs and ballads that circulated throughout Appalachia and that flooded into the valleys of the Cumberland and Tennessee Rivers came from the lips of generations of folk performers. Song, story, and dance culture was bequeathed to early settlers from their immigrant ancestors of Ireland, Scotland, Wales, and England. (Below, CPM.)

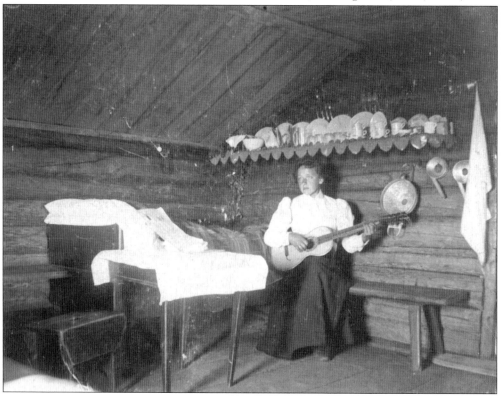

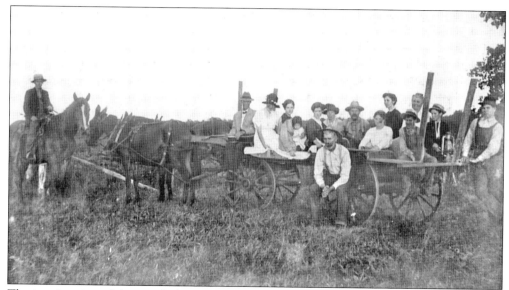

The immigration of the people known as Celts—Scotch-Irish, Scots, Welsh, and English—to Tennessee and the American South was considerable between the early 17th and late 18th centuries. Contemporary writers spoke of many people leaving the Highland of Scotland for the New World. (CPM.)

The reason for this immigration was unbearable living conditions. People left their homes for the promise, or hope, of a chance to continue the farming way of life they had enjoyed in Europe. The desire for land, better prices, fair treatment, unrestricted farming, reasonable tariffs, and an encouraging future were among the reasons people left their homes and countries. (TSA.)

This author's family story is an example of this legacy. Strolling through the Clement-Delap family cemetery in an Alabama county that borders Tennessee, one is reminded that this story is only a few generations removed from modern day. Among those buried there are the author's great-great-great-grandmother, Mary H. Phillips Smith, and great-great-grandparents Stephen and Sarah Jane Smith Delap Clement. Sarah Jane's father, Sterling Smith of Lunenburg County, Virginia, died on August 28, 1828, eight months before she was born. Sarah and her widowed mother, Mary, and other family members began the move to north Alabama through Tennessee from Virginia when Sarah was three years old. (FDS.)

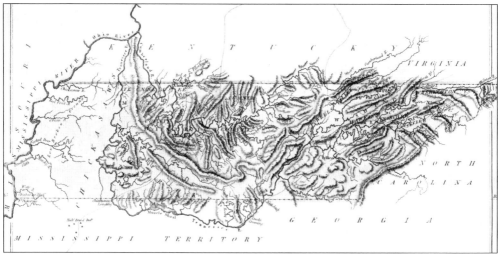

Several things may have inspired ancestor Mary Smith to move with her family to Alabama after Sterling Smith's death. In 1819, Virginia was becoming overpopulated, and Alabama had recently become the 22nd state. In addition, cotton was the new cash crop in Alabama, so the promise of inexpensive, fertile land was alluring. This pioneering spirit and developmental drive had been passed down through Mary Smith's ancestral line. Mary's great-great grandfather William Mayo (the author's seventh great-grandfather) was an English civil engineer who laid out the cities of Richmond and Petersburg, Virginia, and surveyed the line between North Carolina and Virginia. Mayo came to Virginia by way of Barbados in 1723. His father, Joseph Mayo, was from Poulshot, Wiltshire, England, dating back to 1691. (TSA.)

The route Mary and Sarah Smith and other family members took to their new home bordering Tennessee was along the same route as hundreds before them. It is family tradition that they traveled by oxcart along the Great Valley Wagon Road into Tennessee. Others such as Daniel Boone took the Cumberland Gap route following the Cumberland River. After arriving in Tennessee, some travelers settled in the Watauga or Holston Valleys. Others boarded flat-bottom riverboats and followed the same route as John Donelson along the Holston, Tennessee, Ohio, and Cumberland Rivers. The Smith party, however, departed the Tennessee River at Cottonport, Alabama, near present-day Decatur. Other ancestors stopped and settled near the Cumberland Gap area in eastern Kentucky. (TSA.)

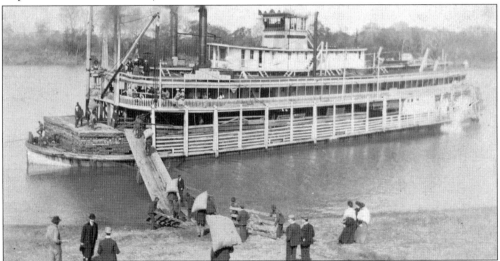

John Donelson traveled from East Tennessee to Nashborough by foot and horseback, arriving December 25, 1779. A second group arrived on April 24, 1780. This group of approximately 60 families established the pioneer settlement that was to become Nashville. These settlers built cabins out of area timber, slept on crude beds of straw, and lived on local game and bread made from corn. According to John Egerton, by 1800, Nashville had a post office, a newspaper, an inn, retail stores, taverns, and a population of growing significance. Steamboats arrived on the Cumberland River by 1819 from New Orleans, defining Nashville's transition from pioneer town to emerging city. (TSA.)

Nashville's first school classroom traveled up the Cumberland River with John Donelson's flotilla. Gen. James Robertson's sister, Ann Johnson, was in charge of the children's instruction. According to John Wooldridge, "Mrs. Johnson organized the children into a school which she taught on week-days and Sundays." (Above, TSA; below, NPL.)

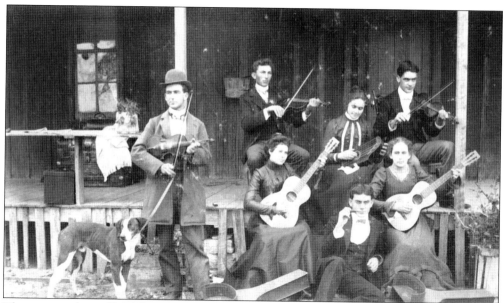

The new settlers of Middle Tennessee adapted to their environment in musical ways, and H. Wiley Hitchcock notes that older themes irrelevant to the Colonial experience tended to be dropped in preference for songs of love and romance, such as "Barbara Allen," or for songs that related to the New World experience, such as "Captain Kidd." Song details were often changed to fit the new American context. In time, new songs were added to the Celtic song and ballad tradition. (CPM.)

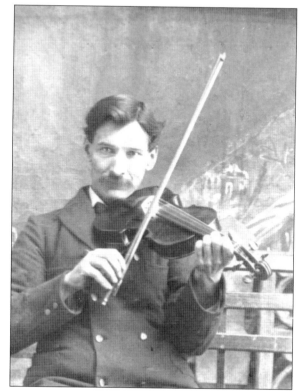

By the last decade of the 18th century, 2 million Scotch-Irish had migrated to the New World. British ballads and songs sung in Middle Tennessee in the early 19th century included "The King's Daughter," known in England as "Lady Isabel and the Elf-Knight" and in parts of the United States as "Pretty Polly." The most common ballad in Tennessee was "Barbara Allen," with as many as 33 versions. One version of the first verse of the ballad goes: "Twas in the merry month of May, / When all the flowers were a-blooming, / Sweet William on his deathbed lay, / For the love of Barbry Allen." (CPM.)

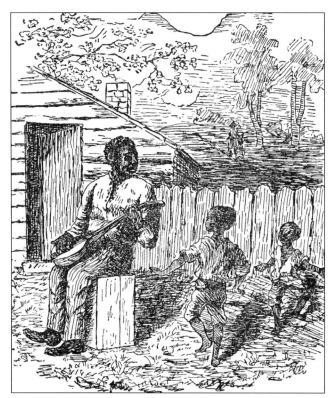

Charles Wolfe reported of the reworking of the British ballad "Wexford Girl" into the Tennessee version, "The Knoxville Girl." The narrator tells of the murder of his fiancée and disposal of the body into the river "that flows through Knoxville town." In his *American-English Folk-Ballads*, Cecil Sharp presents the full text and tunes for ballads he heard in Tennessee that were still living in oral tradition in the early 20th century. (Left, FDS; below, CPM.)

The hundreds of songs sung regularly in the late 18th and early 19th century in Middle Tennessee formed the basis of the scales, harmonies, meters, rhythms, instrumentation, and, in short, every stylistic feature of the early song culture of rural Middle Tennessee and its center, Nashville. The instrumental music of the region was most often produced by string instruments and played by ear. The two instruments mentioned regularly in contemporary accounts were the fiddle and the banjo. One observer wrote, "Do you not hear those sounds of revelry and mirth? The ceaseless tum tum of de ole banjo, and the merry twang of de fiddle and de bow?" (Above, FDS; below, CPM.)

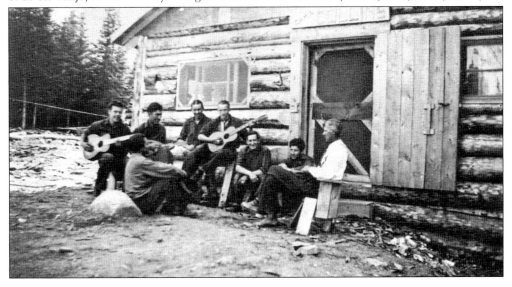

According to A. W. Putnam's *History of Middle Tennessee*, James Gamble may have been Tennessee's first, recorded, professional fiddler. He was recorded carrying his fiddle and wandering from town to town in Middle Tennessee playing for dances. As Putnam recalls, "He read his Bible, and fiddled; he prayed, and he fiddled; asked a silent blessing on his meals, gave thanks, and fiddled; went to meetings, sang the songs of Zion, joined in all the devotional services, went home, and fiddled. He sometimes fiddled in bed, but always fiddled when he got up." (FDS.)

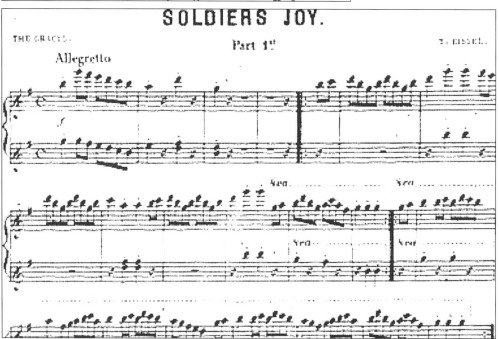

A century and a half later, when bluegrass legend Bill Monroe sang of his fiddling inspiration "Uncle Penn," he references the very fiddle tunes of this era when he quotes "The Boston Boy," "Soldier's Joy," and "Jenny Lynn." These fiddle tunes were passed from fiddler to fiddler throughout Tennessee.

Two

I SOUGHT MY LORD IN THE WILDERNESS

Celts not only loved to sing, play, and dance, as Grady McWhiney relates in *Cracker Culture*, they also liked to "talk, preach, orate, tell stories, and to listen to others do the same." This love for delivering and receiving stories was clear in the religious practices of early 18th century Tennessee settlers. The storytelling inherent to song culture was closely related to the storytelling of preaching and pioneer entertainment in general.

Settlers of Scotch-Irish and English descent established more and more communities in Middle Tennessee. About 50 miles north of Nashville, just over the state line in Logan County, Kentucky, Ambrose Maulding established Maulding's Station or Maulding's Fort. These settlers built their first Presbyterian church between 1789 and 1792 near the Red River. The 1812 gravestone of William McPherson in the church's adjoining cemetery displays the words of Psalm 23 engraved in Gaelic:

Is e Dia fèin a's buachaill dhomh, cha bhi mi ann an dì.
Bheir e fainear gu luidhinn aios air cluainibh glas' le sith
Is fòs ri taobh nan aimnichean thèid seachad sios gu mall

Rev. James McGready left North Carolina for Kentucky in 1798 to preach a fiery and compelling evangelical Christian message to the pioneers of the Logan County settlement of Maulding's Station and to the people in neighboring Tennessee.

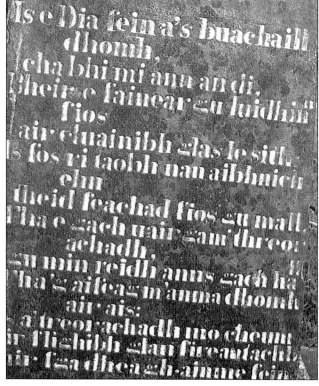

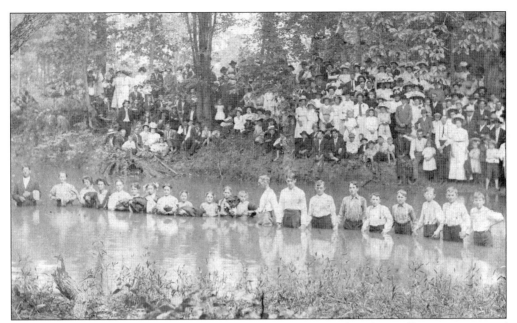

Rev. James McGready came to Kentucky as an itinerant preacher for small congregations of Presbyterians that met at sites on the Red, Gasper, and Muddy Rivers. These sources of water were not only important for survival, but were also convenient for baptisms. McGready, a colorful preacher, brought vivid images of both heaven and hell to his congregants. No one was passive about McGready's message, and his reputation grew by impressive numbers. (CPM.)

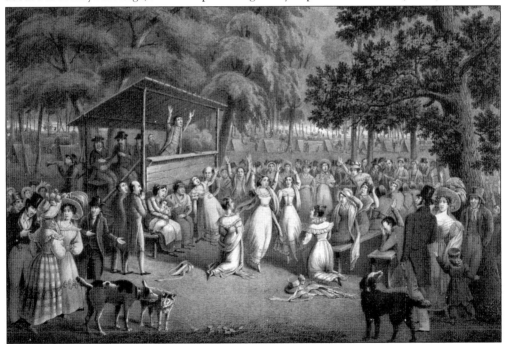

In the summer of 1799, Rev. James McGready's persuasive powers were witnessed as people responded dramatically to his preaching. One observer noted, some of the "boldest, most daring sinners in the country covered their faces and wept bitterly." (LOC.)

At the conclusion of 1800, western Kentucky and Middle Tennessee were delirious with religion. Revivals spread from Logan County (meeting house pictured above) and surrounding areas, to Cane Ridge (meeting house pictured below), and then across the country in what was called the Second Great Awakening. According to contemporary accounts, numbers of miracle-seekers were in the thousands. The harvest of souls was shared amongst Presbyterians, Baptists, and Methodists.

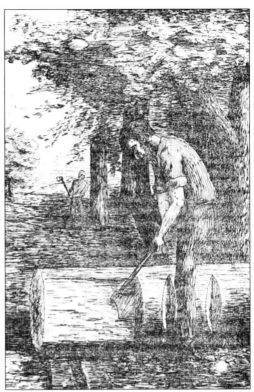

Camp-meeting worshippers sang, prayed, listened to fiery sermons, and lived for 10 to 14 days at a time in the primitive settings. They camped on the ground and kept up religious exercises day and night. Some crowds at locations such as the Cane Ridge were estimated between 10,000 and 20,000. F. D. Srygley, a late-19th-century Nashville minister, described the seating arrangement: "To arrange seats, we placed large logs under the arbor, about ten feet apart, and laid on them rough slabs, split from poplar logs with maul and wedge, about three feet apart, in tiers the full length of the arbor." Srygley's observations and accompanying sketches were published in Nashville in 1891 by the Gospel Advocate Publishing House (below). (Right, FDS; below, NPL.)

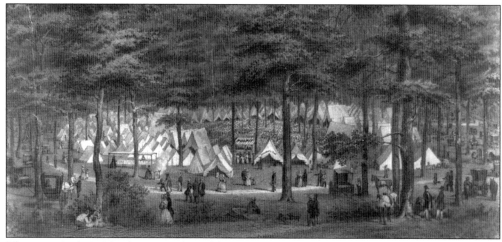

The revival of 1800 broke out in the wilderness of Kentucky and continued in the months and years that followed. One observer recorded the following description: "The nights were truly awful; the camp ground was well illuminated, the people were differently exercised all over the ground—some exhorting, some shouting, some praying, and some crying for mercy, while others lay as dead on the ground." (LOC.)

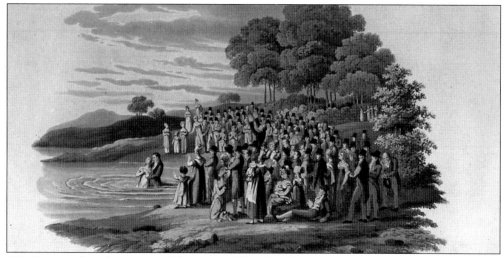

F. D. Srygley describes a typical day in the life of a wilderness camp meeting: "We met at the stand under the brush arbor or clapboard shed for prayers every morning before breakfast. After breakfast we spend about an hour in secret prayer in the woods. At ten o'clock we assembled at the stand again for preaching, which continued till noon or a little after. From noon till two o'clock we took dinner. At two o'clock we assembled at the stand again for preaching, which lasted till four o'clock, after which we spent another hour at secret prayer in the woods. We took supper at five o'clock, and assembled at the stand again for preaching and altar exercises at seven o'clock. From seven o'clock till we adjourned, which was often not till after midnight and sometimes not till daylight the next morning, the exercises consisted of preaching, exhorting, praying, singing, calling mourners, shouting and work in the altar." The spontaneous nature of these gatherings meant that printed music was unavailable. Songs were characterized by a basic verse text, verse and refrain structure, and an easily memorized repetitive choral refrain. At first, these songs were passed on orally from one individual or group to another. Later they became the basis for printed gospel songs. (LOC.)

Evidence of spiritual outpouring came in unusual new public behavior. There was something that came to be called the "laughing exercise"—explosive outbreaks of laughing that were seen as devout and pious. Another sign of devotion was the "barking exercise," where the inspired dropped to their knees at the foot of a tree as if they were a dog treeing a raccoon, supposedly trapping the devil in the limbs above. There was a sound that seemed to emanate from the chest area that was called the "singing exercise," characterized by a melodious chanting by the stricken. (CPM.)

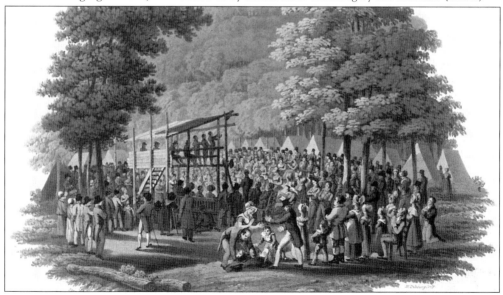

In their excitement, people would jump, dance, clap their hands, swing their bodies, and jerk their heads forward and backward, throwing hats, bonnets, and combs in every direction. The nervous excitement produced muscular contortions called "the jerks," which caused the long hair of women to crack like whips as their bodies and heads jerked back and forth. During these periods of excitement, the whole congregation was thrown into convulsions of laughter, which came to be called the "holy laugh." It would last for hours, and everyone seemed to be seized by the same sidesplitting impulse. The same thing happened in a spirit of fear, which led to regular, steady, and straightforward dancing. (LOC.)

In F. D. Srygley's recollections and images of his childhood at early camp meetings, he states that people came "in droves and threw themselves literally in heaps in the straw which covered the ground in the altar. Some would be kneeling, some reclining on the rude benches about the altar, while scores would be lying prostrate on the ground, all agonizing and shrieking for mercy in an earnestness perfectly distressing to see." (FDS.)

Spiritual fires were fueled in following generations by revival preachers such as Charles G. Finney (pictured), Lyman Beecher, and Dwight L. Moody. Revival preaching was always accompanied by compelling music that appealed to the common person. (LOC.)

The new musical expressions that accompanied the wilderness revivals included a body of religious songs called the "wilderness" spiritual. These songs resembled religious folk songs, but are identified as wilderness songs by textual images and geographical references. Wilderness songs use river imagery, valleys, and other geographical and topographical references common to wilderness camp meetings.

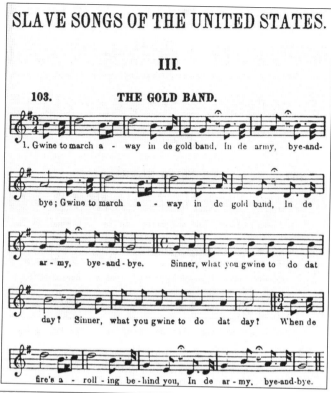

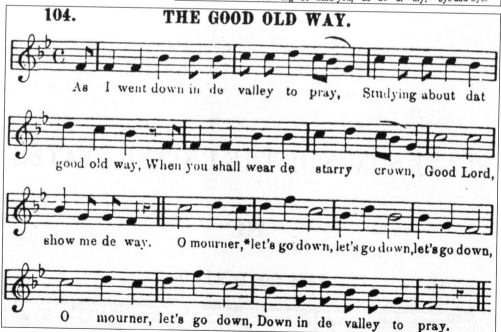

In William Francis Allen's *Slave Songs of the United States*, the author lists several spirituals found in Tennessee, such as "The Good Old Way": "As I went down in de valley to pray, / studying about dat good old way, / When you shall wear de starry crown, Good Lord, show me de way. / O mourner, let's go down, down in de valley to pray."

105. **I'M GOING HOME.**

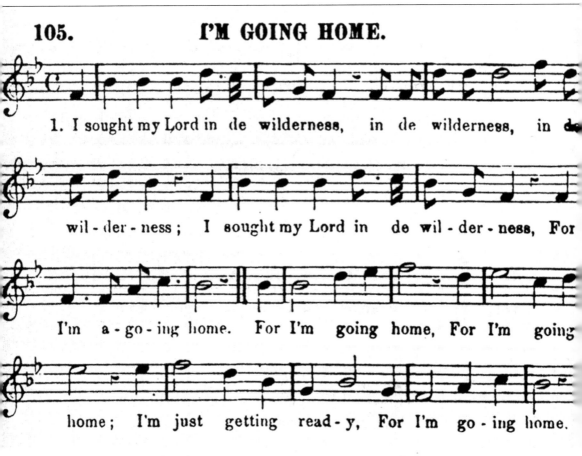

1. I sought my Lord in de wilderness, in de wilderness, in de wil-der-ness; I sought my Lord in de wil-der-ness, For I'm a-go-ing home. For I'm going home, For I'm going home; I'm just getting read-y, For I'm go-ing home.

2 I found free grace in the wilderness,

3 My father preaches in the wilderness.

Another Tennessee example specifically referenced the wilderness as a spiritual destination: "I sought my Lord in de wilderness, For I'm a-going home. / I found free grace in the wilderness . . . / My father preaches in the wilderness . . ." And another contains these lyrics of a wilderness invitation: "Way down in de valley, Who will rise and go with me? / You 've heern talk of Jesus, Who set poor sinners free." "De valley" and "de lonesome valley" were familiar words in the wilderness religious experience. To descend into that region implied the same process as that of the camp meeting's "anxious-seat," the moment leading up to a religious conversion.

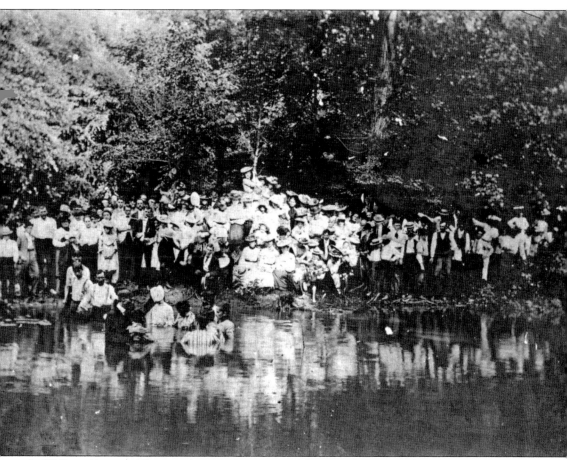

In William Francis Allen's preface to *Slave Songs of the United States*, he lists the spirituals "O Lord, Remember Me" and "Lonesome Valley," which are additional examples of wilderness spirituals. Allen noted spirituals "from the lips of the colored people themselves" in various regions throughout the South. Other well-known spirituals with wilderness themes include "Steal Away," "Go Down, Moses," and "Deep River." (TSA.)

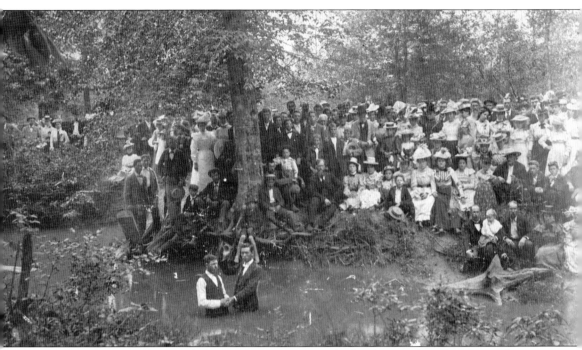

William Francis Allen's work documents an important body of spirituals and gives insight into how spirituals were originally performed: "The negroes keep exquisite time in singing, and do not suffer themselves to be daunted by any obstacle in the words. The most obstinate Scripture phrases or snatches from hymns they will force to do duty with any tunes they please, and will dash heroically through a trochaic tune at the head of a column of iambs with wonderful skill . . . the voices of the colored people have a peculiar quality that nothing can imitate; and the intonations and delicate variations of even one singer cannot be reproduced on paper." (TSA.)

William Francis Allen states that his desire was to publish the 60 spirituals found at Port Royal, but as more material was discovered, the scope of the project included spirituals from additional states. He writes that the songs "from Tennessee and Florida are most like the music of the whites." By this he means the hymns and camp meeting songs that emerged from rural Tennessee camp meetings. He observes there was no singing "in parts" with the spirituals: "The high notes, all in unison, and the admirable time and true accent with which their responses are made, always make me wish that some great musical composer could hear those semi-savage performances. With a very little skillful adaptation and instrumentation, I think one or two barbaric chants and choruses might be evoked from them that would make the fortune of an opera."

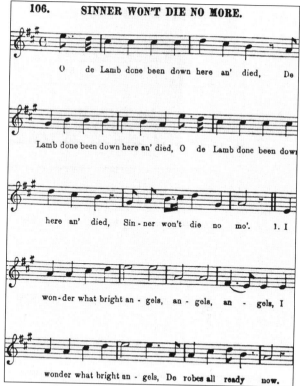

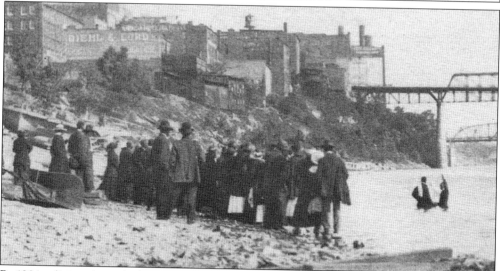

By 1804, religious fervor had spread throughout the South. Not everyone bought this new message, however, which paved the way for new divisions within denominations. Presbyterians, Methodists, Baptists, and other groups experienced divisions between the revivalists and the traditionalists. With theological justifications carefully defined and passionately argued, the era of the Second Great Awakening produced new denominations. Within miles of Nashville, religious groups such as the Shakers, Cumberland Presbyterians, Southern Baptists, National Baptists, Church of Christ, Freewill Baptists, General Baptists, and Methodist Episcopal denominations found a home and, for some, a publishing center. (TSA.)

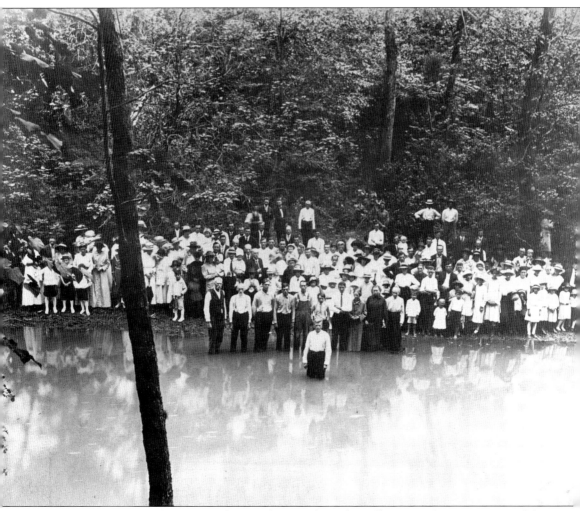

In H. Wiley Hitchcock's *Music in the United States*, the author offers a useful categorization of the religious songs that developed throughout Tennessee during this era. He uses the term "spiritual folk song" for this body of song, and the divisions within it are religious ballads, folk hymns, and revival spiritual songs. A convergence of these religious folk songs led to the revival hymn, which grew in popularity throughout the 19th century. (TSA.)

Three

NORTHERN MINSTRELSY AND SOUTHERN SPIRITUALS

To a large degree, religious gatherings offered a form of entertainment as well as spiritual enlightenment to early settlers. Hymns and spirituals were sung by large groups of people, offering recreation as well as faithful expression. Domestic entertainment continued to include old and new songs and ballads perpetuated from the Scotch-Irish and English traditions accompanied by and danced to the sounds of the fiddle, guitar, and banjo.

As Nashville grew, a new style of entertainment swept the masses in the form of blackface minstrelsy. Minstrelsy began in the 1830s in New York City and boomed in the Northeast. Minstrel touring companies found a welcome audience in northern and southern cities.

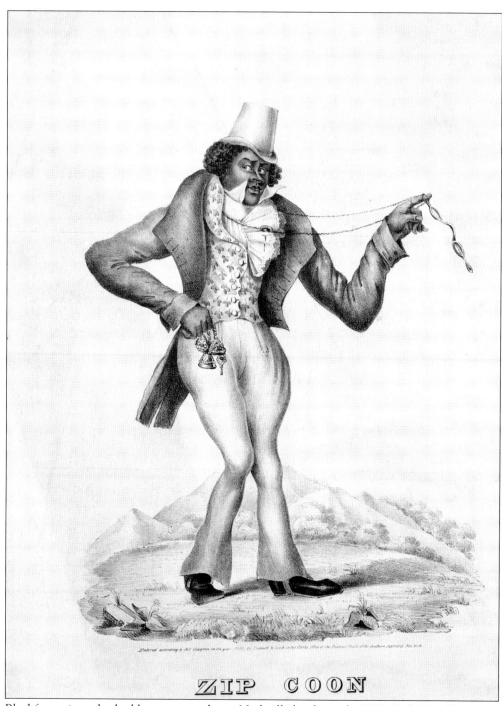

ZIP COON

Blackface minstrelsy had become popular in Nashville by the early 1830s. Bob Farrell came to Nashville for a minstrel show in November 1833. Farrell was a circus performer who turned to the growing popular form of minstrelsy. He claimed to be the creator of the "Zip Coon" character that became a standard character in blackface minstrelsy. His amusing local advertisement offered audiences the opportunity to hear him "sing 70,000 songs, more or less." (LOC.)

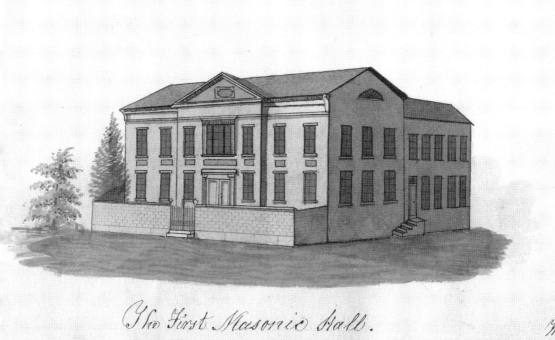

The First Masonic Hall.

The venues for performances in Nashville during the early decades of the 19th century included an assembly room in the City Hotel, the Nashville Female Academy, the Nashville Academy of Music, and the Masonic Hall (pictured). The Nashville Academy of Music and the Nashville Female Academy's halls were used primarily for student activities. The Masonic Hall was erected in 1818 and housed many better-known musical events in Nashville. The following description of the Masonic Hall was printed in the October 13, 1838, *Daily Republican*: "I had admired the plain, substantial building, but had never seen the interior. A very polite German gentleman, with spectacles on his nose . . . kindly invited me to enter a large room, where I found some hundred persons quietly seated . . . the benches were nicely arranged in rows, and the walls plentifully decorated with hog lard candles, emitting a 'dim and religious light' and a delicious fragrance resembling the odor of fried bacon. At the extreme end was the orchestra, just large enough to accommodate Mueller and his piano Mueller played a very pleasing and extremely difficult solo on the violin, but the audience kept up a running fire of conversation during the whole concert. The flute serenade was not calculated to wake anybody or lull them to sleep—its great merit was its brevity I publish this that our readers at a distance may learn how innocently and rationally an evening may be passed by the admirers of imported talent in the good city of Nashville." (WAE.)

Newspaper accounts offer a glimpse of classical concert life of the early decades of 19th-century Nashville. The first people to receive attention were the performers of the city, both resident and those traveling through. The following program was listed on July 6, 1819, and was presented by "Mr. Richardson, late teacher of the Band at the circus of Richmond and Mrs. Richardson, a celebrated singer and dancer from Philadelphia": Mozart's Overture to the *Zauberflote* / Song, Oh no my love, no / I have loved thee / A Medley on the Piano Forte / Comic Song / Ah! Vous Dirais, French Air with Variations for the Piano Forte. The concert concluded with "The Star Spangled Banner," possibly the first performance of this song in a Nashville concert. (TSA.)

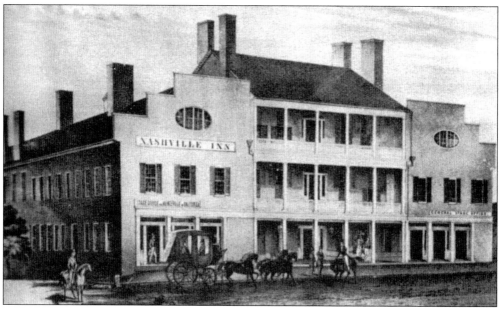

On February 17, 1821, the *Nashville Whig* announced that a "musical society" would assist in a concert at the Nashville Inn. This musical society was one of the first of its kind and continued operation for some time. In 1822, an announcement appeared in the newspaper for a performance of the opera *Paul and Virginia* with no mention of a composer, sponsor, or admission price. The work was most likely Rodolphe Kreutzer's popular opera of this era. The production took place at the "theatre." (NPL.)

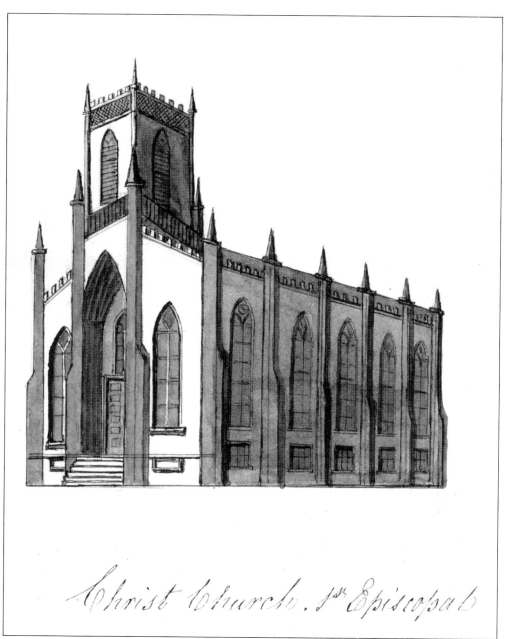

Christ Church, 1st Episcopal

An editorial in the *National Banner* on October 13, 1835, announced a benefit concert on October 14, organized by John Marek, a German immigrant and operator of a private music studio in Nashville. Concerts were used during this period to raise funds for a variety of relief efforts; this one was for the benefit of two children who were left homeless by the death of their father, James Aykroyd, a local music dealer: "The public attention is solicited to the Oratorio to be given at the Episcopal Church. The talents of Mr. Marek, the leader, have been exhibited and appreciated at the concerts given by him during the last winter, and assisted as he will be by professional gentlemen and several amateurs of the city, we may be sure to have an interesting musical treat." (WAE.)

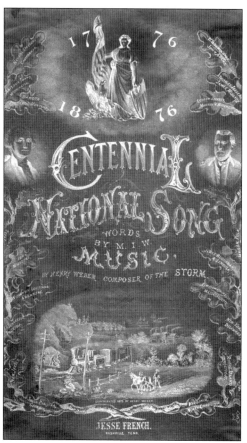

The program consisted of works by Rossini, Mazzinghi, Mason, Haydn, Martini, and others. On May 28, 1836, the following "Grand Concert" was announced: "The Ladies and Gentlemen of Nashville are respectfully informed that Mr. Groves, the distinguished solo performer on the clarinet; Mrs. Groves, the admired Vocalist, from New York, and Herr Von Weber from Germany. Concert of Vocal and Instrumental Music, on Monday Evening, May 30th at the City Hotel. Overture to commence at eight o'clock. Herr Von Weber will preside at the Piano Forte. Selections have been made for the occasion from the most eminent composers in Europe." Then, on July 26, 1836, a concert was given by a Mr. and Mrs. Ganderbeeck (he a violinist and she a harpist) and a Mr. Vorelli. The repertoire consisted of a variety of classical pieces and popular contemporary pieces, as well as "Hail Columbia" and "Yankee Doodle." The Union Harmonic Society was formed on February 16, 1844, for the purpose of "more effectually uniting the musical talent into an association." The object of this society was the improvement of native talent, the elevation of musical taste, and the performance of musical concerts—sacred and secular, vocal and instrumental.

In April 1845, Nashville witnessed its first truly international concert artist with the appearance of Norwegian violinist Ole Bull (1810–1880). His performance repertoire consisted of popular music, his own compositions based on American tunes and themes, and Norwegian folk songs. According to comments in the *Republican Banner* newspaper, his concert "was numerously and fashionably attended." In addition to his 1845 concerts, Bull returned again in April 1853 and in March 1856. His 1853 concert included nine-year-old vocal phenomenon Adelina Patti and pianist Maurice Strakosch. Bull's 1856 tour also featured Ann Spinola, Anna Vail, Louis Schrieber, and Franz Roth. (LOC.)

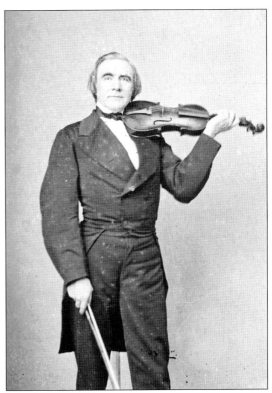

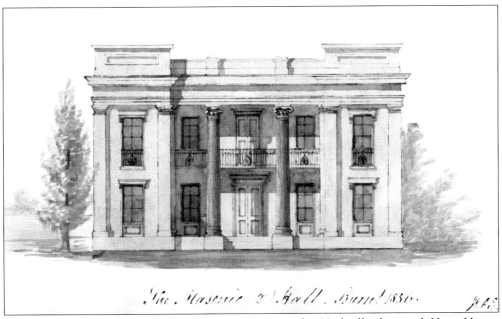

In June 1847, Camillo Sivori, a pupil of Paganini, appeared in Nashville along with Henri Herz, a professor and pianist from the Royal Conservatoire of Paris. In April 1848, popular pianist Maurice Strakosch, known as the "Pianist to the Emperor of Prussia," gave a concert in Nashville. He was assisted by Senora Carlotta Casini, a singer with the New Orleans Opera Company. Strakosch returned to Nashville on April 24, 1849, for a concert given at the Masonic Hall. (WAE.)

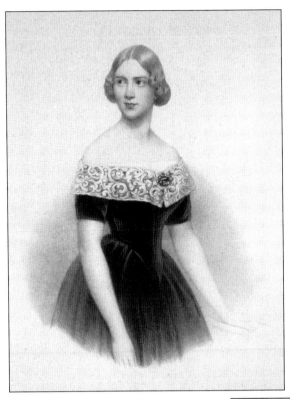

The concert that overshadowed all others during this era was the appearance of vocalist Jenny Lind (1820–1887), known as the "Swedish Nightingale," in her American tour. P. T. Barnum of circus fame was the manager and promoter of Lind's American tour during the early 1850s. She played to sold-out crowds throughout America, where her popularity was enormous. Her voice and personality combined to win the hearts of the country, so much so that her name became an endorsement for every type of merchandise imaginable. (Left, LOC; below, TSA.)

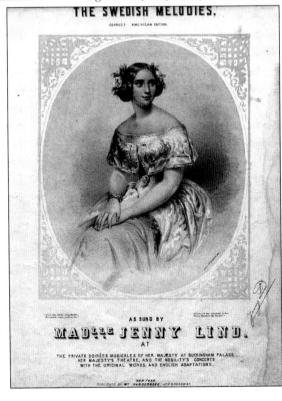

George Upton noted the following observation of Jenny Lind's appearance in American cities: "Stores in the eastern cities displayed Jenny Lind bonnets, gloves, coats, hats, parasols, combs, shawls, and jewelry. Butchers advertised Jenny Lind sausages and hardware stores made a specialty of Jenny Lind teakettles. Restaurant proprietors caught the fever and inserted 'a la Jenny Lind' after the choice dishes on the menu cards. Jenny Lind pancakes became famous." (Right, MPL; below, LOC.)

M'LLE JENNY LIND'S
FIRST GRAND
CONCERT.

Monday, June 9, 1851.

DRESS CIRCLE.
BOX No. 5

No. 575

TAKE NOTICE.

This Ticket must be retained, to secure possession of the Seat bearing a corresponding number, which will be shown by the Ushers in attendance. Sit with your back to the number.

The Ticket accompanying this is to be given up at the entrance. All persons should be in their seats by half past 7 o'clock.

P. T. Barnum

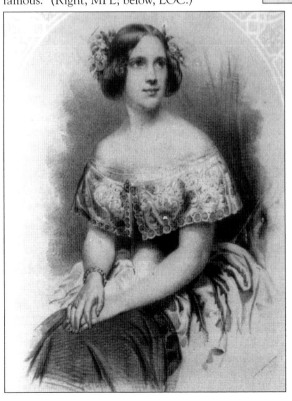

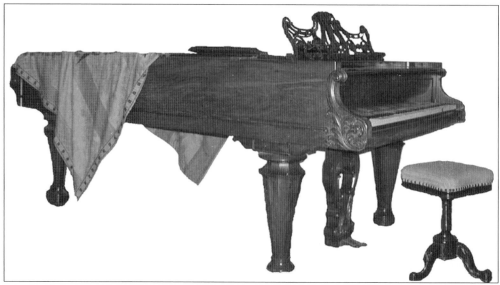

On March 31 and April 2, 1851, Jenny Lind gave her concerts in Nashville at the Adelphi Theater. She was joined by conductor Jules Benedict, baritone Signor Belletti, and violinist Joseph Burke. A contemporary observer in Nashville noted that she sang "The Last Rose of Summer," "Perche non ho del viento" by Donizetti, "The Echo Song," her signature "Home, Sweet Home," and "one or two other old songs." The piano that was used in the concert became a prized possession and eventually was given to the Ward-Belmont School. It resides today in the Belmont Mansion of Belmont University. (Both BU.)

The opera *Lucia di Lammermoor* was presented at the Adelphi Theatre on May 26, 1854, by Signor Luigi Arditi's Italian Opera Company utilizing orchestral musicians as well as a full chorus. An announcement of the full Italian cast, conductor, stage manager, and "prompter" appeared in the May 25th edition of the *Daily Gazette*. This was the first full operatic production thought to be staged in Nashville. The Arditi Company followed this production with Donizetti's *Lucrezia Borgia*, Rossini's *Barber of Seville*, and Bellini's *La Somnambula* and *Norma*. Other concert artists appearing in the early 1850s included female vocalists Teresa Parodi, Anna Bishop, and Amalia Patti, tenor Henry Arthurson, and popular pianist Maurice Strakosch. Professional concert bands were also popular throughout the decade, and Horn's Brass Band became a favorite in Nashville. (NPL.)

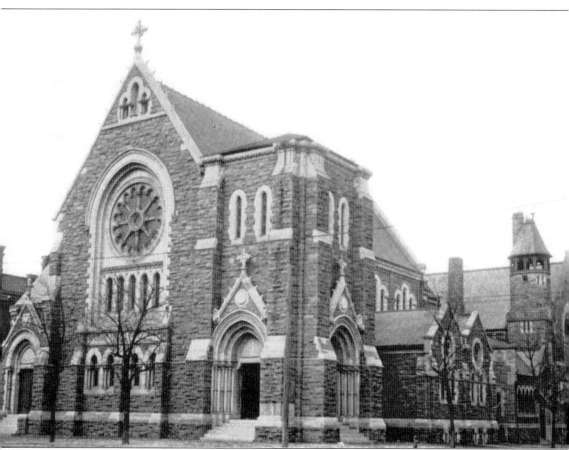

Christ Episcopal Church provided musical leadership in the early years of Nashville's growth as a city, and other churches played an important role in the early history of Nashville music making. Haydn's oratorio *The Creation* was presented at Christ Episcopal Church on February 16, 1858, the first full performance of this work in the state. The chorus was made up of only 18 singers and was conducted by German immigrant Henry Weber. (NPL.)

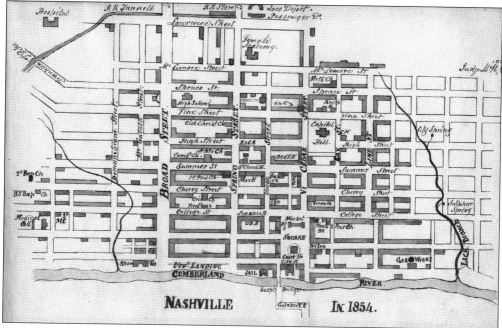

Nashville had matured as a city of the arts by the mid-1850s. Maurice Strakosch returned in February 1859 and performed Rossini's *Stabat Mater* with his "Combined Italian Opera and Concert Company." In 1859, Nashville joined many other cities in the celebration of the 100th birthday of German poet Friedrich Schiller. The German community organized a Schiller Music Festival on November 10 consisting of choral and piano works. (NPL.)

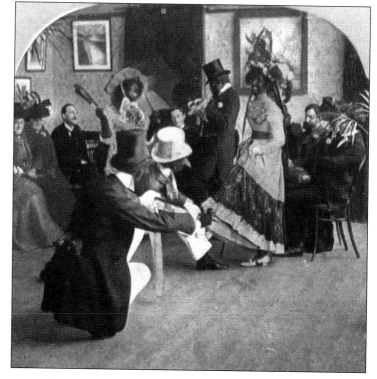

Blackface minstrelsy remained popular in Nashville. On June 26, 1846, an account of a concert given by the Northern Serenaders minstrel troupe of New York was listed: "Grand Concert of Ethiopian Melodies by the Northern Serenaders from New York for three nights, at Masonic Hall, Nashville." (CPM.)

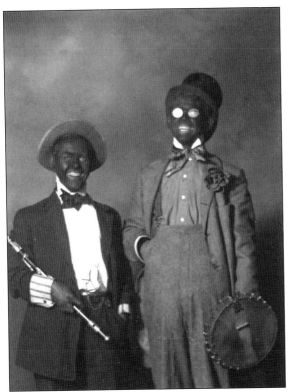

Blackface minstrelsy used three types of songs in the course of a show: ballads, comic songs, and specialties. The minstrel show acted as a distribution agent for songwriters, spreading songs throughout the country. These songs used African American dialect, substituting words such as "de, dem, dere, and dey" for the words "the, them, there, and they." Stephen Foster later began to call his songs "plantation songs." (CPM.)

As minstrelsy became more popular, magicians, acrobats, and trained animals all performed in the shows. In the typical minstrel show, a performance would be divided into two parts. The main highlights of the first part included the specialty roles of the interlocutor (a person who takes part in a dialogue), the musical star, and the comedians. The highlights of the second part were the variety section, including song and dance numbers; acrobats; men playing combs, quills, and novelties as imitations of banjos; and finally the stump speech. (LOC.)

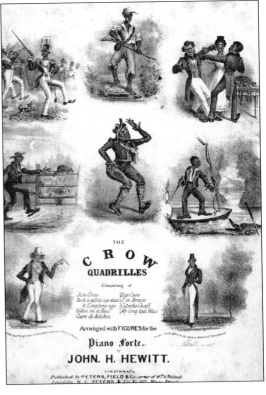

The stump speech was a speech given by one person near the end of the show, performed to convince the crowd of something important, usually something coming up in the next performance. The finale of the show was a skit performed by a white man imitating a black man on a plantation. Included in the skit were individual songs and dances that concluded with an enthusiastic group song-and-dance number. (TSA.)

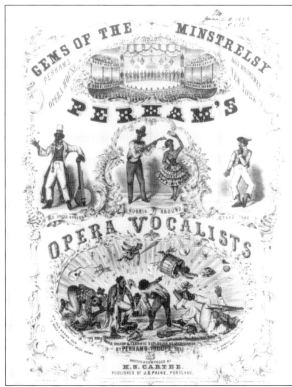

Minstrelsy gained popularity throughout the United States in the 1850s, reaching a peak in popularity in Nashville in the spring of 1857. Traveling minstrel groups appearing in Nashville included Lynch's Harmoneon Troupe, Balfe's Original Sable Opera Troupe, Old Joe Swensy's Virginia Minstrels, the Empire Minstrels, Aeolian Minstrels, Sanford's Pioneer Minstrels, and Mat Peel's Campbell Minstrels. Peel's Minstrels played in Nashville for several weeks beginning on March 23, 1857, and according to the *Union and American* newspaper, the theater "had never been so densely crowded, not even when Jenny Lind had been the chief attraction." The newspaper continued, "Nor for one night, or two nights, but night after night for over a week the house was crammed from pit to dome without any abatement in appreciation or enthusiasm." (LOC.)

47

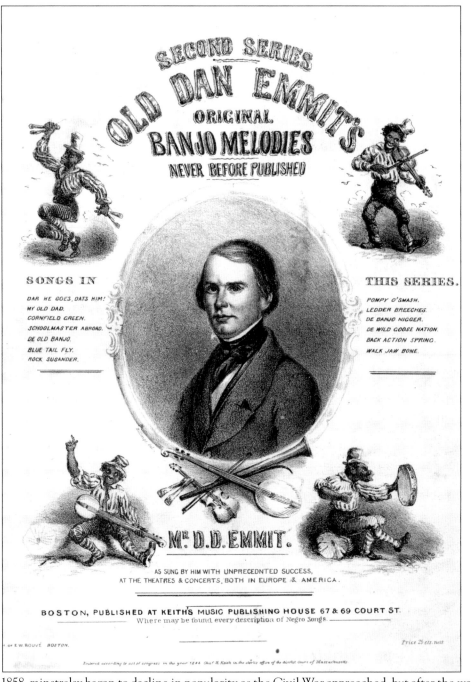

By 1858, minstrelsy began to decline in popularity as the Civil War approached, but after the war, minstrelsy returned to popularity. Skill and Gaylord's Minstrels and Cal Wagner's Minstrels were among the most popular of the traveling groups to perform at Nashville's Masonic Hall. Later venues for minstrelsy in the 1870s included the Olympic Theater and the Grand Opera House. New troupes touring the area included Callendar's Famous Georgia Minstrels; Haverly's Minstrels; Harry Robinson's Minstrels; the New Orleans Minstrels; Kelly and Leon's Minstrels; the Original Georgia Minstrels; and Barlow, Wilson, Primrose, and West's Minstrels. (TSA.)

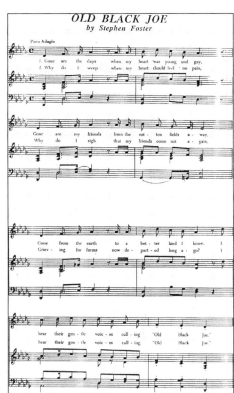

The popularity of minstrel songs and ballads fed directly into the growth in gospel songs. Sunday school songs were patterned after the secular folk songs of the 1820s and 1830s, and provided the form for developing the new gospel song hymnody of the middle and late 19th century. Minstrel songs from composers such as Stephen Foster and Dan Emmett became the song models for evangelical songwriters. Stephen Foster's "Old Black Joe" was adapted note for note to the gospel text "I Love Him." Tunes such as this abound in the hymnals and gospel songbooks published in Nashville.

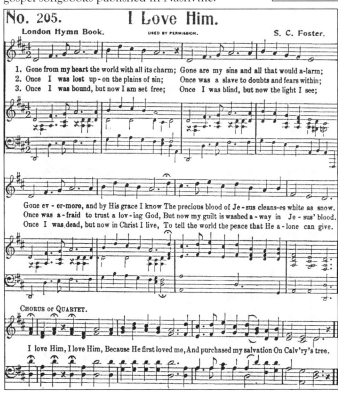

Gospel song composers eagerly adapted the musical styles of secular songs, including those by Stephen Foster. Only after a style became familiar and pervasive did religious musicians make their adaptations. Into this stream of song came the songs of the Civil War and the gospel songs of the church and evangelistic crusade. (TSA.)

Four

THE UNITED NATIONS OF NASHVILLE

Adding to the established Irish, Scotch-Irish, and English settlers, another wave of Europeans arrived in Nashville in the 1830s and 1840s. In these middle decades, musicians from Germany, Italy, France, and other European countries settled in Nashville, providing European classical musical leadership to the community through private instruction as well as through the emerging academies where they found employment.

In contrast to the earlier European settlers, these new immigrants brought professional skills and conservatory musical training to their new home in Nashville. The *National Banner* newspaper noted that T. V. Peticolas had relocated to Nashville on April 23, 1826, to teach flute "to young gentlemen." Immigrants established the first schools of music, music retail stores, and professional concert programs in Nashville. It was the Germans more than any other group that made the strongest, permanent impact on music in 19th-century Nashville. German leadership was evident in education, concert life, and in musical commerce.

In March 1866, the German language newspaper the *Tennessee Staatszeitung* began publication with John Ruhm as editor. This newspaper was strongly Republican and was an advocate for public school development. This paper continued to be published through 1869. Additional German language newspapers published in Nashville included the *Nashville Demokrat* and the *Cumberland Blaetter*, both edited by Theodore Trauernicht, A. S. Jourdan, and R. Papendieck. (Above, CPM; below, TSA.)

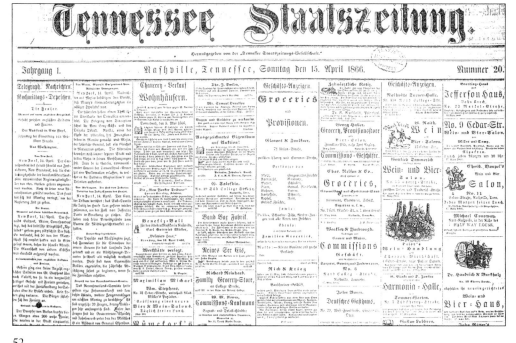

Among the leading immigrant business leaders was Adolphus Heiman, who was born in Potsdam, Prussia. Heiman was the architect that designed the suspension bridge that spanned the Cumberland River in Nashville. Physician Philip Harsch came to Nashville in 1844 after receiving his education at the University of Giessen. Otto Ruppius was listed in the census of 1850 as a professor of music at the Nashville Female Academy. He was also a writer of popular fiction. Other immigrant occupations listed in the census included tailors, bakers, merchants, coopers, shoemakers, butchers, cabinetmakers, grocers, and a variety of other skilled occupations. Throughout the publication of the *Tennessee Staatszeitung*, Albert Bornstein advertised regularly as an instructor in the area of vocal and instrumental music. (Above, CPM; right, TSA.)

Albert Bornstein,

Lehrer in der

Vocal= und Instrumental=

Musik.

Besorgt Musik für Bälle, Prozessionen, Concerte u. jede andere Gelegenheit.

Bestellungen werden in den Musik=Handlungen der Herren Benson, McClure und Luck angenommen.

Office: Ecke Church und Vine=Str.
17. März 6mts.

Carl Casper Giers (left) was born on April 28, 1828, in Bonn, Germany. He came to the United States in 1845 and made Nashville his home in 1852. In 1855, he began his career as a photographer. During the Civil War, Giers photographed soldiers from both sides of the war as Nashville changed hands. When Giers died, his photography business was sold. Otto Giers (below), Carl's son, was born January 25, 1858. He partnered with other German American Nashvillians to form Thuss, Koellein, and Giers Photography. Otto became a well-known documentary photographer. (Left, NPL; below/left, personal collection; below/right, CPM.)

According to Kenneth Rose, John B. West was the "dean" of early Nashville music dealers. Rose points to the firm of J. B. West as the focal point of musical activity during the 1830s and 1840s. West advertised consistently in the newspapers, stating that he "has now at the Music Room on Market Street for sale one Patent Piano-Forte of superior tone and workmanship." The announcements in the paper for West's enterprise demonstrated a steady demand for musical instruments. (CPM.)

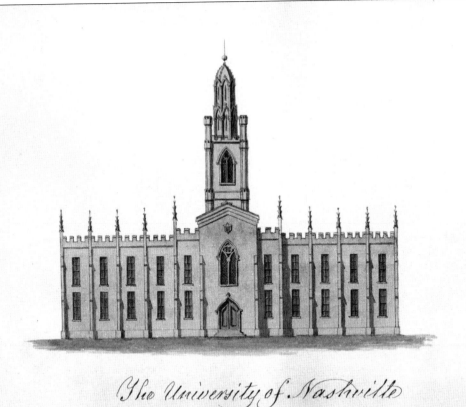

The University of Nashville

The list of music business leaders during this era includes H. A. Eichbaum, James Aykroyd, D. A. Robertson, James Diggons, C. C. Norvell, and Joseph Dwyer—all of whom focused on musical enterprise and fed off of the influence and activities of the musical academies and educational institutions of Nashville. The University of Nashville and the Nashville Female Academy were dominant in general education in the South during the first half of the 19th century. The Nashville Female Academy, established in 1816, included music in its curriculum and depended on professors from abroad for their musical expertise. (WAE.)

NORDDEUTSCHER LLOYD, BREMEN

S.D. „KRONPRINZESSIN CECILIE."

The new German "professors" as they were called, fostered a high level of musical development. In an editorial published in the *Nashville Republican and State Gazette* on January 13, 1831, the writer states: "At the present day a knowledge of music is considered an indispensable accomplishment in the education of a female; but so short and imperfect is the course allotted to this subject that the Young Miss is suffered to 'come out' with a very imperfect idea of its elementary principles, and with her knowledge confined to a few easy and popular airs which she had practiced at school, of which she is tired of learning, and by the repetition of which her friends are sadly wearied . . . to such and all others, who are properly instructed in the elementary lessons, we would recommend the Euterpeiad as an invaluable auxiliary which cannot fail to heighten the relish and improve the taste for this delightful science." (TSA.)

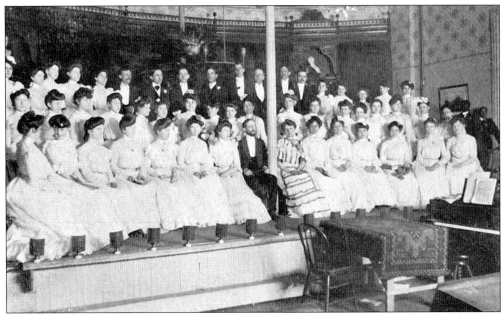

Kenneth Rose states that nearly all music education at this time was stressed only as an adjunct to a polite and "ornamental" culture. Music was a subject proper to the education of young women, added to a list of other proper subjects that included painting, needle work, and social deportment. Nevertheless, this desire for musical training established a need for serious instruction, which the trained German immigrants filled.

The group of European musicians that came to Nashville included J. E. Jungman, a pianist who came to the faculty of the Berry Seminary in 1833; John Marek, listed as "a celebrated professor" from Germany; Basil Knapp, a pianist and organist; Henri Corri, a professor of music and member of the Royal Academy of His Majesty's Chapel in London; and Henry C. Walsh, a faculty member of the Nashville Female Academy. (CPM.)

The "professors" residing in Nashville brought with them classical concert repertoire from European concert halls. This included the music of Haydn, Beethoven, and Mozart. New venues for performance, such as the Odd Fellows Hall, were added to the city landscape. In October 1830, a Nashville concert was noted that included movements from Handel's *Messiah* and Haydn's *The Creation*. The concert concluded with the "Hallelujah Chorus." (WAE.)

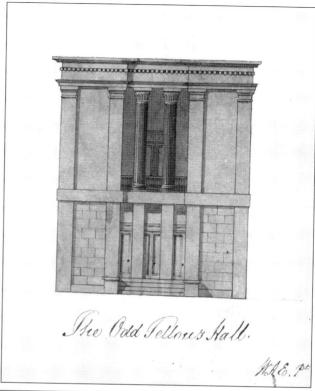

The Odd Fellows Hall.

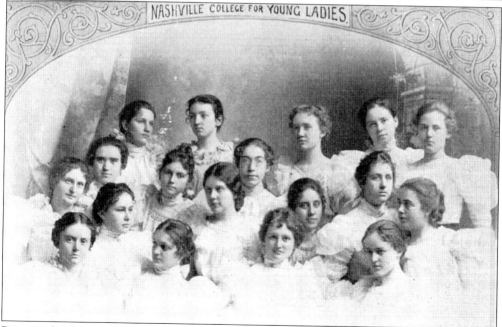

Private schools and academies grew from the 1830s and into the mid-19th century. Institutions offering music instruction included Veuve's Female Academy, the Peticolas Female School, Sprague's Female Academy, Mr. Brown's Select School for Young Ladies, and a long list of other schools particularly suited for the musical instruction of young women.

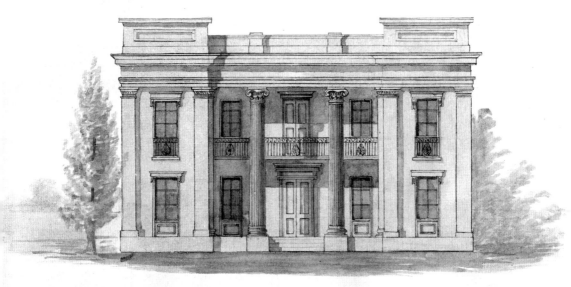

The. Masonic (2º) Hall. Burnt 1856.

The Masonic Hall was the venue for many of the early classical concerts. Joining the early group of professional musicians in Nashville, four additional influences to the city's musical expansion blossomed in the late 1830s: William Nash, Emil Heerbruger, C. F. Schulz, and William Harmon. Nash came to Nashville in June 1836, offering classes in piano, organ, and singing, and setting up shop on College Street near the center of town. The building was known as Mr. Nash's Concert Hall and later became the home of the Nashville Academy of Music, which was organized by Nash in November 1838. Kenneth Rose states, "The Nashville Academy of Music was established and conducted on a high plane, and in its province became as worthy of the city's support as the older and more famous Nashville Female Academy. Its standards were excellent and it was managed in an efficient manner suggestive of modern conservatory methods." (WAE.)

William Nash and his singing wife also taught at the Nashville Female Academy, where he directed the department of music. He was a Mason, was active in several fraternal organizations, and ran a local music dealership for general music supplies and merchandise. Nash and his wife were mentioned regularly in accounts of concerts. Charles Crain commented, "It is possible that no musician during the nineteenth century exerted more influence on the musical life of Nashville than did William Nash." Following the work of Nash, additional German musicians began work in Nashville in 1837—Emil Heerbrugger, C. F. Schultz, William Harmon, and Henry von Weber. Heerbrugger was known as the "little musician." He arrived in Nashville from Hanover, Germany, by way of the Italian Opera Company in New York. Before arriving in Nashville, he taught at Gettysburg in Pennsylvania and then in Franklin, Tennessee. In addition to his teaching, Heerbrugger was a noted composer and a retail music merchant. Heerbrugger's establishment was later called "E. Heerbruger's Music and Fancy Store" with his full title listed as "Emil Heerbruger, Professor of Music, Union Street." (Right, NPL; below, TSA.)

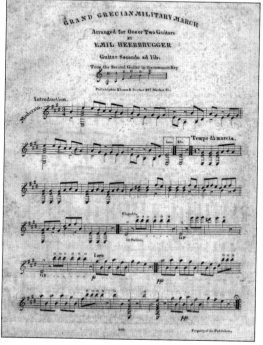

Emil Heerbruger was Nashville's most prolific published composer during the first half of the 19th century. Compositions included "Grand Grecian Military March," "L'Union," "Hungarian Waltz," "Song of a Bird of Paradise," "Cicilian Waltz," and "Swiss Air." The titles of these pieces betray the international influences of the day on musical taste, and the various dedications demonstrate the patrons and sponsors of Heerbruger's enterprise. (UOM.)

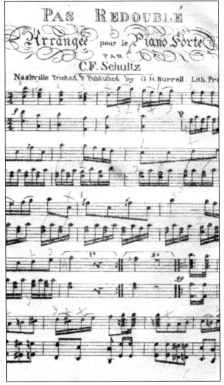

C. F. Schultz came to Nashville in August 1837 from Mecklenburg-Schwein, Germany. He received his musical education in Berlin. A pianist as well as a composer, Schultz gave lessons in guitar and music theory. Compositions by Schultz include "Impromptu Waltz," "German Song," "March," "L'Impatience," and "Pas Redouablé," the earliest known sheet music published in Nashville, which was composed around 1838 and printed by G. H. Burrell. William Harmon completed his musical studies in Europe and came to Nashville by way of Baltimore. According to Kenneth Rose, Harmon was the first American-born musician with European training to relocate to Nashville. He arrived in the city in March 1838 and connected immediately with William Nash at the Nashville Academy of Music. The *Daily Republican* newspaper printed the following statement regarding Harmon's musicianship: "Much was added by the accompaniment of Mr. Harmon on the flute and on the violin—a young man lately arrived in our city, and associated with Mr. Nash, who by his obvious skill as a scientific and practical musician on several instruments, and his modest, obliging and kind deportment, will find ample patronage as a teacher." (NPL.)

Other names appearing in Nashville as active music performers and teachers during the early 19th century include F. Evers; Charles Roehes, also a German; F. R. Cooke, a violinist; the Reverend Dr. Campbell, a pastor and vocal instructor; a Mrs. King, who founded a Musical Academy in 1837 along with her sister "Miss Christian"; A. C. Winicker, arriving in 1840; and pianist F. A. Keraney, who arrived in 1836. Musical societies saw their beginning in Nashville during the decade of the 1830s. In 1837, the Musical Fund Society was established to bring a high standard of music performance to Nashville. Emil Heerbruger was at the center of this movement. The stated purpose of the Musical Fund Society was to give frequent and stated musical entertainment for the city. The society gave monthly concerts for at least a year. The first concert of the Musical Fund Society was given on December 26, 1837, for the benefit of Heerbruger. *The Daily Republican* gave notice of this concert: "The Amateurs and Professionals of our city have been recently united together, for social and benevolent purposes, as 'The Musical Fund Society of Nashville,' and will give their first regular concert at the Masonic Hall this evening." Following this premiere, ongoing monthly recitals took place through 1839. Composers represented on the programs included Rossini, Meyerbeer, Bellini, and Weber. (NPL.)

From 1836 to 1839, more than 40 concerts were presented in Nashville. The repertoire continued to be a blend of classical works, popular songs of the day, and works by local composers. Charles Edward Horn performed in Nashville in a concert in April 1837, giving three recitals during his visit. He was sponsored by William Nash and James Diggons. Newspaper accounts listed programs by a Mr. McLeary, a Mr. and Mrs. Fallon, Herr Schmidt, William Nash, F. C. Unger, Mrs. A. B. Shankland, and Henry Russell. (WAE.)

The Capitol of Tennessee. Cost 1,000,000.

Europeans continued to staff Nashville's musical academies and private teaching studios in the 1840s. Signor Borra, an Italian pianist and violinist arrived at this time, as did a Mr. Swain, a pianist and singer, who received his training in Europe. Other instructors included L. R. Marshall, L. C. Brennen, T. J. Cook, J. M. Swenson, and the previously mentioned Otto Ruppius. In 1843, Nashville was named the capital of the state of Tennessee, and the city had established itself as a serious entertainment center with many touring artists, as well as local performers. (WAE.)

Five

NOT JUST WHISTLING DIXIE

In 1819 and 1820, a defining national crisis had erupted over the spread of slavery into Missouri, causing a national debate over the issue of slavery and the concept of the Union itself. This debate reached a climax in 1861 when the country went to war with itself. The beginning of 1860 brought to a crescendo the turbulence and storm that was coming. The topic of war was foremost in the thoughts of Nashvillians. When war finally broke out, cultural activities in Nashville came to a halt.

By the eve of the Civil War, Nashville had made great cultural advancements. Since the arrival of the first steamboat in 1818, Nashville had grown into a leading river port with its key position on the Cumberland River. Five railroads entered the city by 1861, fanning out to small towns in surrounding areas. The population was now 37,910, making Nashville the eighth largest Southern city, and with its strong transportation and communication system, it was becoming a regional distribution center.

In May 1861, the Tennessee state legislature voted to secede from the Federal Union, joining other Southern states in the newly formed Confederacy. Nashville was the first major Confederate city to fall to the Union. It was occupied by military forces longer than any other American city during or since the Civil War. By 1862, all public schools in the city were closed as a result of the occupation by the Federal army. Over the next four years, Tennessee participated in major battles on its own soil and contributed significant leadership to the struggle.

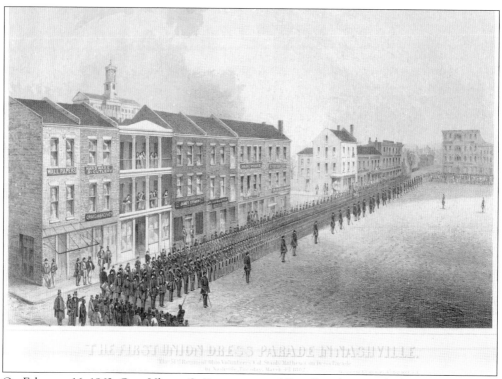

On February 16, 1862, Gen. Ulysses S. Grant captured Fort Donelson on the lower Cumberland River and gained control of the waterway to Nashville. By February 23, Union troops had advanced on Nashville, and on February 24, 1862, Nashville surrendered to the Union army. For the balance of the Civil War, Nashville was one of the most strategic and fortified Union locations. (Above, LOC; below, NPL.)

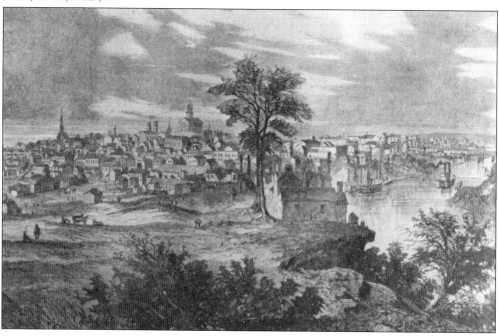

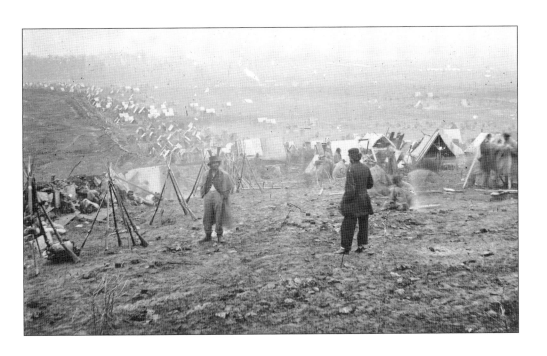

The only serious threat to Nashville came from the Confederate army in November and December 1864. On December 15–16, 1864, Gen. John Hood and an army of 23,000 Confederate troops advanced on Nashville. The battle was over quickly, resulting in the Confederate army's retreat. (Both, NPL.)

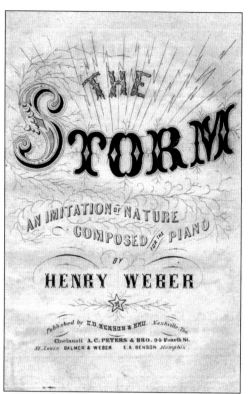

German musicians rose to the forefront of music making and teaching in Nashville just before the Civil War. In 1855, German immigrant Charles Hess was one of the most revered musicians of the city. The *Union and American* newspaper printed the following on January 2, 1855: "Herr Hess is a gentleman who has lived in this city for several years, and who has by his gentlemanly correct behavior, gained the esteem of his fellow citizens." In September 1855, Hess partnered with fellow German Henry Weber as coleaders of the Nashville Academy of Music, located at 24 Vine Street. Weber was born on April 15, 1812, in Marburg, Germany, where he received his musical training. His early composition "Hail Washington" was published by the C. D. Benson & Bro. Publishing company of Nashville in 1842. Weber was known as a prolific composer with songs including "The Centennial National Song," "Blow, Bugle, Blow," "Tennessee Battle Song," and the enormously popular hit "The Storm," which achieved a wide circulation with an estimated 2 million copies sold. (Left, TSA; both below, NPL.)

The Civil War produced hundreds of songs that chronicled the events, issues, characters, and ideals of both sides of the conflict. Although the lack of newspapers during the period makes documentation of performances difficult, orchestras and musicians continued to perform as indicated by the following order published by John A. Martin, colonel and provost marshal of the Union army in Nashville: "The places of amusement in this city are patronized liberally by Union officers and soldiers, and courtesy demands that their sentiments and feelings shall be consulted in the performances. The orchestras at every place of amusement will, in future, be required to play at least three of the National airs each night." (UOM.)

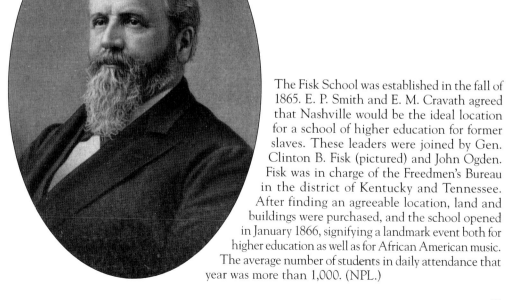

The Fisk School was established in the fall of 1865. E. P. Smith and E. M. Cravath agreed that Nashville would be the ideal location for a school of higher education for former slaves. These leaders were joined by Gen. Clinton B. Fisk (pictured) and John Ogden. Fisk was in charge of the Freedmen's Bureau in the district of Kentucky and Tennessee. After finding an agreeable location, land and buildings were purchased, and the school opened in January 1866, signifying a landmark event both for higher education as well as for African American music. The average number of students in daily attendance that year was more than 1,000. (NPL.)

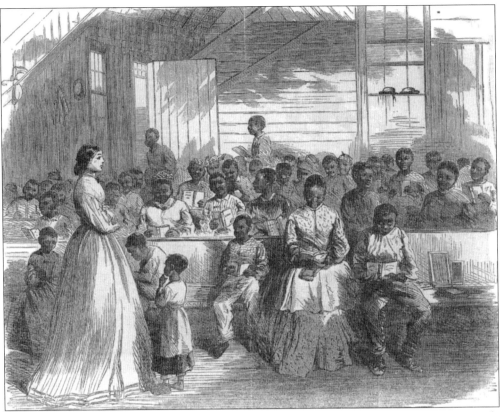

The years following the Civil War were ones of reconstruction and reconciliation. Progress made before the war had to be reestablished, particularly in education. Public schools reopened in 1865. John Ruhm, editor of the German language newspaper *Tennessee Staatszeitung,* used his editorial space to advocate for better schools for Germans, as well as for the general population, resulting in the opening of new schools. (Above, FDS; below, NPL.)

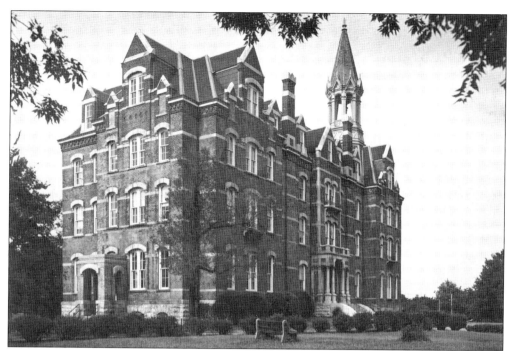

The American Missionary Association, founded in 1846 for the purpose of establishing schools in the South for slaves, found renewed purpose after the Civil War. Nashville became a center for black education with the founding of Fisk University (pictured above), Central Tennessee College (pictured below), Roger Williams University, and Meharry Medical College. (Both, NPL.)

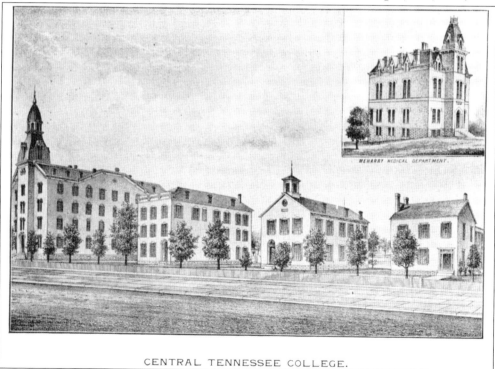

CENTRAL TENNESSEE COLLEGE.

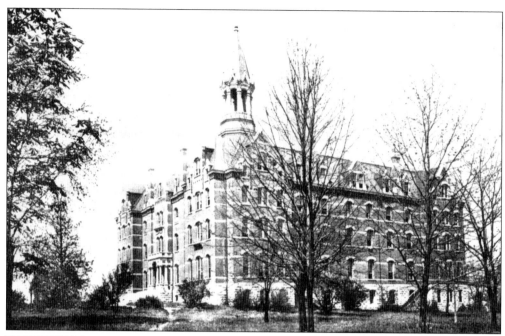

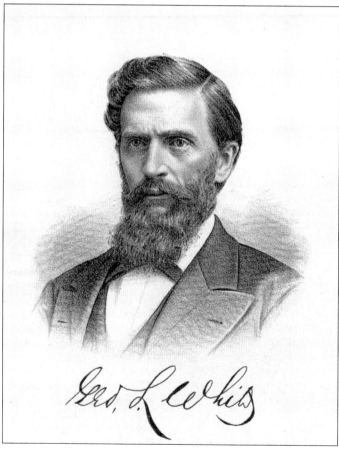

George L. White was listed as a teacher in vocal music on the original Fisk University faculty. He assembled a choral group in the first year of the school, and by 1870, the choir performed the cantata *Esther*. They toured to Memphis and Chattanooga, and performed for the National Teachers Association in Nashville. White was also the treasurer and business manager for Fisk, and as such, he had detailed knowledge of the school's financial situation. The success of the early choir tours inspired White to use the ensemble as a development tool. On October 5, 1871, White led a tour of the Fisk choir to Ohio. In Columbus, the choir took on the name the Jubilee Singers. (Both, NPL.)

Concert repertoire of the early Jubilee Singers included popular minstrel songs such as "Old Folks at Home" and popular English and Scotch ballads. Later the Jubilee Singers began incorporating spirituals into their programs. Up to this time, spirituals had been reserved for devotional times. It was not long before audiences recognized the beauty and uniqueness of the spirituals, and due to their growing popularity, the Jubilee Singers began shifting the spirituals to occupy a major portion of their concert programming. (NPL.)

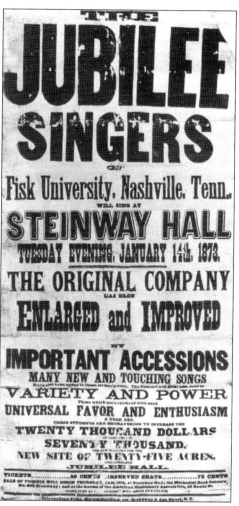

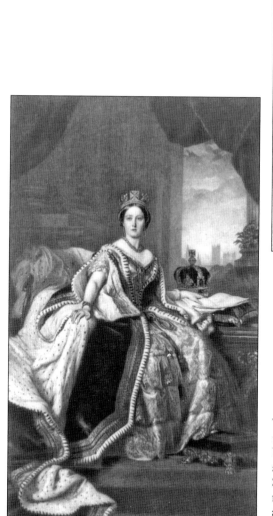

The success of the Jubilee Singers' concert tours led to financial success for Fisk University. In 1874, the group undertook a one-year concert tour to England and Scotland where they were enthusiastically received. They sang for Queen Victoria and Prime Minister Gladstone, and toured England again in 1875. (LOC.)

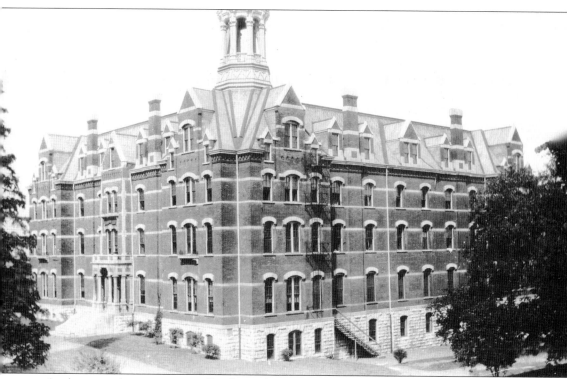

At the start, the instruction offered at Fisk School was at a primary level due to the fact that under slave laws, not even the basics of education had been available. As Nashville began to make provisions for the education of black children in public schools, Fisk focused on higher education, paving the way in 1867 for the charter of Fisk University. In September 1867, Fisk University began operations as an academic and normal school, enrolling 87 students in the academic department and 41 students in the normal department. The need for capital improvements to the buildings at Fisk led to one of Nashville's most significant contributions to world music. (NPL.)

By 1881, J. B. T. Marsh published 112 songs sung by the Jubilee Singers during the period 1870 to 1880. These songs included "John Brown's Body," "We are Climbing to Zion," "The Gospel Train," and "Steal Away." When the Jubilee Singers performed at the World's Peace Jubilee in Boston in June 1880, Marsh records how they forever changed the shape of music history: "When they sang that grand old chorus, 'Glory, Glory, Hallelujah', twenty thousand people were on their feet. Ladies waved their handkerchiefs. Men threw their hats into the air, and the Coliseum rang with cheers and shouts of 'The Jubilees! The Jubilees forever.' " (NPL.)

On May 7, 1880, Adam K. Spence organized the Mozart Society at Fisk University, conducting the group for the next 11 years. The Mozart Society maintained an active musical life in Nashville during the years that the Jubilee Singers were on concert tour. They sang Mendelssohn's *St. Paul*, *Elijah*, and Handel's *Messiah*. In 1885, Fisk began an academic department dedicated specifically to music education. This new initiative added the study of voice, organ, music theory, music history, and music education to the established performing ensembles.

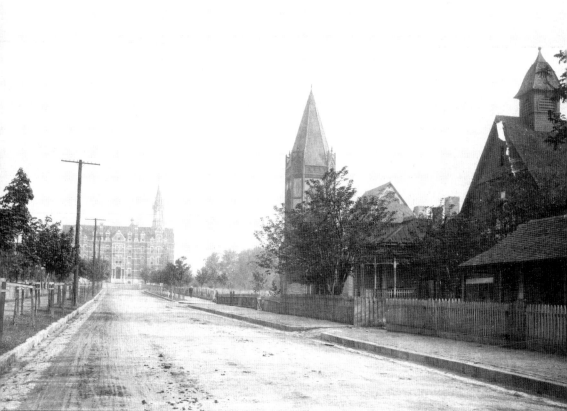

The financial success of the Jubilee Singers' concert tours contributed to Fisk University's ability to purchase land for a new campus and to construct new buildings, including Jubilee Hall. According to a Mr. Woodridge, "with the first $20,000 earned by the Jubilee Singers twenty-five acres of land were purchased to the northwest of the city, one of the most eligible and beautiful locations that could have been selected—the former site of Fort Gillem during the war." The dedicatory address by Gen. Clinton B. Fisk for the school's Jubilee Hall credited the Jubilee Singers for their concert work in the United States and England. Students assembled for the first time in the new building on January 3, 1876. (NPL.)

Divisions between North and the South were not limited to politics. Division also existed in matters related to music and music instruction. The differences between hymn and gospel song practice and publication were particularly distinct. Two methods of musical instruction emerged in the two geographical areas. (RS.)

C, or Alto clef shows the position of the notes as follows:

	A La ▭	Space above
G	Sol ◯	Fifth line
F	Fa ◱	Fourth space
E	La ▭	Fourth line
D	Sol ◯	Third space
C	Far ◱	Third line
B	Me ◇	Second space
A	La ▭	Second line
G	Sol ◯	First space
F	Fa ◱	First line
E	La ▭	Space below

The F clef or Bass clef, is for male voices, and shows the notes thus:

	B Me ◇	Space above
A	La ▭	Fifth line
G	Sol ◯	Fourth space
F	Fa ◱	Fourth line
E	La ▭	Third space
D	Sol ◯	Third line
C	Fa ◱	Second space
B	Me ◇	Second line
A	La ▭	First space
G	Sol ◯	First line
	Fa ◱	Space below

MEASURES. Measures are short subdivisions of the music staff separated by drawn directly across it which divide it into short sections, or measures. Each ...re is a time unit, as will appear later, and the lines so separating the measures ...measure bars. A broad bar, or a phrase bar, as it is sometimes called, is often used ...measure bar, but its main purpose is to define the beginning and the ending of a ...of poetry. A double bar, which consists of two broad bars placed side by side, marks ...lose or end of a composition.

NOTES. Notes are musical charcters placed on the staff to represent sounds ...nes, and they were so arranged as to produce the tune desired. The position of ...notes on the staff is what is known as pitch of tones. Only four different shaped ...eaded notes are used in this book, viz.: Fa, Sol, La, Mi, and the examples set out ...part of Section 5 above, show the position of these four notes on the staff of the ...ctive Clefs mentioned.

A TABLE OF THE COMPARATIVE LENGTH OF NOTES.

A whole note is white with no stem, thus:

A half note is a white note with a stem, thus:

A quarter note is a black note with a stem, thus:

An eighth note is a black note with a stem and flag, thus:

A sixteenth note is a black note with a stem and two flags, thus:

A thirty second note is a black note with a stem and three flags, thus:

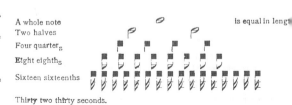

A whole note	is equal in lengt
Two halves	
Four quarter₅	
Eight eighth₅	
Sixteen sixteenths	

Thirty two thirty seconds.

When a dot is set to the wright of the note it adds one half to its length. A dotted whole note is equal in length to three half notes, ect.

A dotted whole note ▭• is equal to ☐ ♩ or ♩ ♩ ♩ or ...

A dotted half note ♩• is equal to ♩ ♪ or ♪ ♪ ♪ or ...

A dotted quarter note ■• is equal to ♪ ♪ or ♪ ♪ ♪ or ...

Thus, it appears that the Semibreve is the longest note used in music and it is ... measure note. Some modes of time, however, require a dotted Semibreve to fill a... ure, while other modes require shorter notes.

8. **RESTS.** Rests in music are marks of silence and should be observed as... The singer should quit when one is reached and sing again after it is passed. T... a rest that corresponds exactly in length with each and every note used.

In the North, the European traditional practice of round-note notation prevailed, as well as a hymn tradition based on slow harmonic rhythms, parallel thirds and sixths, and the use of common major keys. This tradition, known as the Reformed or Progressive Movement, promoted musical instruction through public schools, choral societies, music normal institutes, and the publication of sacred, educational, and popular music. The South was more conservative and maintained the folk traditions and customs taught by the old, 18th-century singing schools. This tradition was characterized by rapid harmonic movement, parallel fourths and fifths, and minor and modal keys. Hymn notation in the South was characterized by the Character Notation Group. This method of music education was based on such pedagogical methods as letter and numerical notation, as well as four and seven shape-note tune books. Nashville maintained these traditions in both singing schools and hymnal publications. In the North, hymnbook publications were rectangular; in the South, oblong.

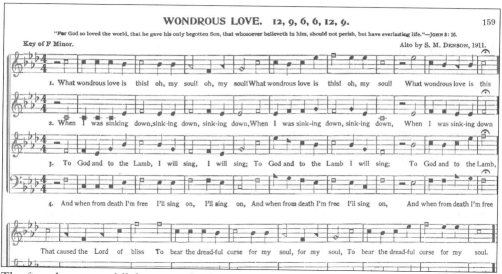

The first shape-note folk hymn used a four-shape system of notation called "fasola." This first appeared in *The Kentucky Harmony*, compiled in 1816 by Ananias Davisson. Tennessee was quick to follow Kentucky's lead with the 1818 publication of Alexander Johnson's *Johnson's Tennessee Harmony*. Tennessee compilers published their own books throughout the first half-century, expanding to a system of seven shaped notes, or "doremi" notation, in the 1840s and 1850s.

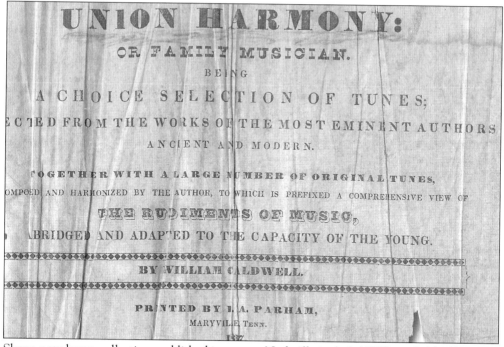

Shape-note hymn collections published in or near Nashville included William Caldwell's *Union Harmony* (Maryville, 1837); Allen D. Cardin's *United States Harmony* (Nashville, 1829) and *The Western Harmony* (Nashville, 1829); John B. Jackson's *The Knoxville Harmony* (Madisonville, 1838); Andrew W. Johnson's *American Harmony* (Nashville, 1839) and *The Eclectic Harmony* (Shelbyville, 1847); and J. D. M'Collum and John B. Campbell's *The Cumberland Harmony* (Nashville, 1834). (RS.)

NEW LIFE;

OR,

SONGS AND TUNES

FOR

OOLS, PRAYER MEETINGS, AND REVIVAL (

BY

M. McIntosh & W. G. E. Cunnyng

NASHVILLE, TENN.:

ERN METHODIST PUBLISHING H
1882.

One shape-note singer gave the following account of his singing experience: "The books we used had seven different shapes, for notes, to represent the seven degrees of the scale, and no teacher I ever knew in those days would have recognized his favorite and best known song if he had seen it in 'round notes.' I had been to several singing-schools, and, in fact, had about finished my musical education, before I ever heard of such a thing as 'round notes,' and the question was discussed throughout the country as to whether any man could possibly learn a new piece of music written in 'round notes.' " In the North, urban centers were of great influence on religious singing practice; in the South, rural audiences were dominant. In the North, education resembled European practice; in the South, singing schools were rural and recreational. Singing societies organized by churches and held at churches contributed to the publication of a long list of hymnbooks and resources for group singing and instruction. (Both, RS.)

GRACE AND GLORY:

A Choice Collection of Sacred Songs,

ORIGINAL AND SELECTED,

FOR

SABBATH-SCHOOLS, REVIVALS, ETC.

BY
D. E. DORTCH,
Columbia, Tenn

EDITED BY
W. G. E. CUNNYNGHAM,
Sunday-school Editor.

Early Tennessee preacher F. D. Srygley recalls, "We had no Sunday-schools, but singing-schools flourished in every neighborhood. Ten days was the usual length of such schools, and it was customary to teach them only two days in each week. This stretched a school of ten days over five weeks, which just about covered the time between fodder-pulling and cotton-picking." Srygley describes a typical singing-school day: "We met at eight o'clock in the morning, brought our dinners with us, and sang till five o'clock in the evening—nine hours a day, hard singing, every day in the week for five weeks on a stretch, right through the hottest part of the summer! That's the way I learned to sing!" (RS.)

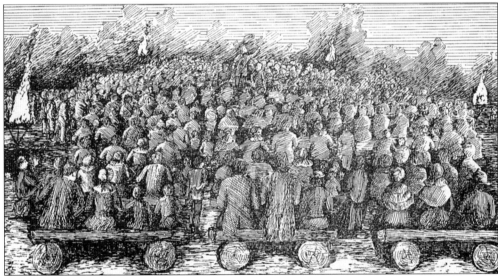

Singing-school classes sat on long benches in a hollow square, and the teacher stood in the middle of the square. The leader would move about in this middle area, working his way through the various treble, tenor, counter, and bass sections. The treble corresponded to the modern tenor, the tenor corresponded to the soprano, the counter to the alto, and the bass to the bass. Women sang treble. As the leader beat time vigorously and with long sweeps of the arms and hands, every singer was required to closely imitate his every movement. His chief accomplishment was the ability to sing any part in the music, and whenever bass, tenor, counter, or treble lagged behind or broke down in the performance, the leader would run to the support of the wavering line and bring up the stragglers. (FDS.)

THE

New Harp of Columbia:

A SYSTEM OF MUSICAL NOTATION,

WITH A NOTE FOR EACH SOUND, AND A SHAPE FOR EACH NOTE.

CONTAINING A VARIETY OF MOST EXCELLENT

PSALM AND HYMN TUNES, ODES AND ANTHEMS,

HAPPILY ADAPTED TO

CHURCH SERVICE, SINGING-SCHOOLS AND SOCIETIES.

ORIGINAL AND SELECTED.

BY M. L. SWAN.

W. T. BERRY & CO., NASHVILLE, TENN.

J. B. LIPPINCOTT & CO., PHILADELPHIA.　　　J. P. MORTON & CO., LOUISVILLE, KY.　　　JOEL WHITE, MONTGOMERY, ALA.
PATTERSON & FITCH, ST. LOUIS, MO.　　　AND BY BOOKSELLERS GENERALLY.

Gospel songbooks continued to be published in Nashville in the mid-18th century. Composers and publishers such as M. L. Swan published songbooks, and later song leaders and songwriters such as Homer Rodeheaver (1880–1955) emerged from the traditional congregations into a larger itinerant platform in the form of evangelistic crusades. Rodeheaver came from upper East Tennessee and partnered with evangelist Billy Sunday, popularizing a new form of religious song called the gospel song. (RS.)

Six

ATHENS OF THE SOUTH

In 1785, when Nashville was still a part of North Carolina, the state legislature established Davidson Academy in the city, taking the first step to make Nashville an educational hub in the South. This effort resulted in a one-room building of stone. In 1806, Davidson Academy was rechartered as Cumberland College and moved to College Street. Andrew Jackson chaired the committee that supervised the building erected for the college. On November 27, 1826, the Tennessee legislature passed an act to incorporate Cumberland College as the University of Nashville.

Travel to and from Nashville was made easier by the completion of a bridge over the Cumberland River in the early 1850s. The bridge was designed by German immigrant Adolphus Heiman. As a result of advances in transportation, the city witnessed a fast pace of growth that continued throughout the 19th century.

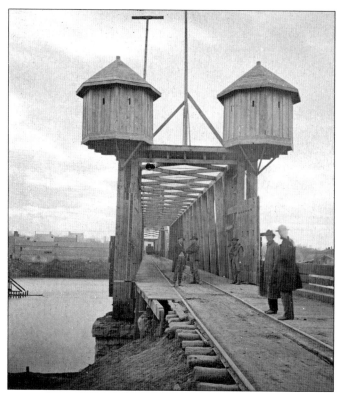

The growth of population, affluence, and ease of transportation made Nashville increasingly attractive to touring artists and musical companies. The number of concerts given increased, as did the number of musicians and teachers that made Nashville home. This was particularly the case for musicians with European roots. Kenneth Rose states that "musicians with European antecedents and education made Nashville their home, employed by the better academies or attracted by the obvious advantages offered by the town's location and growing reputation. Their influence was felt, and their contributions were considerable and important." (NPL.)

In 1816, a committee formed to establish an academy for young women in Nashville. The Nashville Female Academy was established in 1817. Dr. Thomas B. Craighead delivered the dedicatory address on August 3. The second term of the academy began in February 1818, and a Mr. Leroy was added to the faculty as a professor of music. This addition led to an important contribution to the musical life of the community. Additional private schools were established in Nashville in the first two decades of the 19th century, and by the 1830s, Nashville had a number of academies, schools of instruction, and other teaching centers dedicated to music education. These enterprises joined the established Nashville Female Academy and Academy of Music in an effort to train young people of the city in the rudiments of music and the appreciation of concert music. (NPL.)

The *Nashville Whig* newspaper printed the following announcement on April 7, 1816, from the Nashville Musical Society:

> At a meeting of the Nashville Musical Society held in their music room, April 6, 1816, the following resolutions were passed, to wit:
>
> Resolved: That this society deem it expedient to give concerts, the more effectually to enable them to pay the expense of said society, and to purchase music and musical instruments for the use of same.
>
> Resolved: That this society solicit the aid of gentlemen who wish to cultivate a taste for music.

Concert announcements appeared frequently in the newspaper, with performance repertoire consisting of an assortment of classical music, popular songs of the day, and new compositions by local composers. In 1851, the Nashville Academy of Music was revived, and in October 1852, the best musicians of Nashville founded the Philharmonic Society. This society signaled the arrival of several new teachers and performers, including pianist and composer Charles Hess, violinist Felix Simon, vocal and instrumental teachers Hermann S. Saroni, a Professor Gorenfle (listed as a "blind flutist" from Germany), and piano tuner and repairman A. Kaufmann. (TSA.)

The Nashville Female Academy continued to grow and in 1860 had an enrollment of 593. In addition to full-time students, a number of students enrolled specifically for private classes in art and music. In 1861, fees for classes in music instruction at the academy were $60 for vocal or instrumental music, $10 for the use of a piano, $5 for the use of a guitar, $100 for instruction in harp and use of an instrument, and $10 for membership in the college choir. Books used for vocal music instruction included *Songs of Zion, The Singing Bird* by Bradbury, *Carmina Sacra, Tara's Harp, The Musical Bouquet*, and *The Operatic Album*. English immigrant Mary Robinson was listed as a vocal music instructor on the Nashville Female Academy faculty. Robinson joined a large roster of European teachers, including Camille Brunet and Athalie Casche, both having studied at the Conservatoire Imperial with Henri Herz. (CPM.)

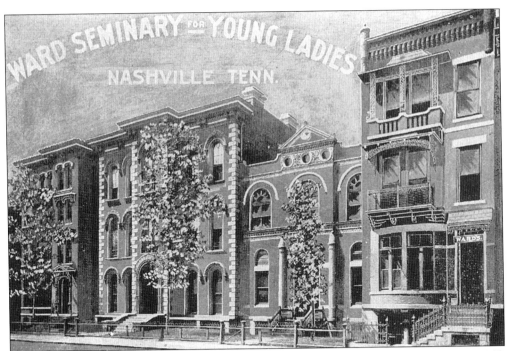

The Nashville Female Academy was closed in 1862 as a result of the Civil War. But in 1865, Presbyterian minister Dr. William E. Ward opened the Ward Seminary for Young Ladies, and within a few years, the school had nine music teachers on the faculty. (Both, NPL.)

Two of the most active departments of the Ward Seminary for Young Ladies were the art school and Ward Conservatory of Music. The catalogue for the conservatory stated the following: "The Ward Conservatory affords superior advantages for the study of Music in all its branches. Instruction is given in Piano, Organ, Violin, Mandolin, Guitar, Banjo, Zither, Cornet, Flue, 'Cello, Harp, Voice Culture, Sight Singing, Chorus Singing, Harmony, Theory, and Musical History."

Fritz Schmitz (left) became director of violin at the Ward-Belmont Conservatory of Music. Later known as Ward-Belmont College, the conservatory was a high school and junior college for women. Located on Adelicia Acklen's Belmont estate, the school later became Belmont College. Clara M. Allison was an early principal at Ward-Belmont. The following words were given in memorial to Professor Schmitz at his death on November 29, 1917: "He is dead, the sweet Musician. He has moved a little nearer to the Master of all music, to the Master of all singing." (Both, NPL.)

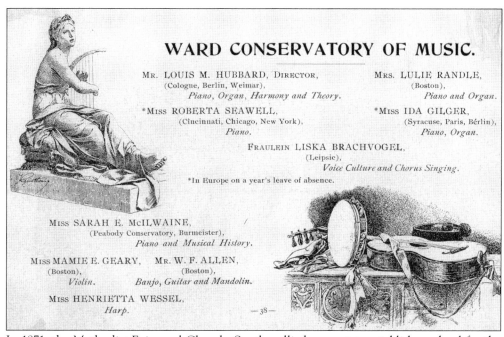

WARD CONSERVATORY OF MUSIC.

Mr. LOUIS M. HUBBARD, Director,
(Cologne, Berlin, Weimar),
Piano, Organ, Harmony and Theory.

Mrs. LULIE RANDLE,
(Boston),
Piano and Organ.

*Miss ROBERTA SEAWELL,
(Cincinnati, Chicago, New York),
Piano.

*Miss IDA GILGER,
(Syracuse, Paris, Bérlin),
Piano, Organ.

Fraulein LISKA BRACHVOGEL,
(Leipsic),
Voice Culture and Chorus Singing.

*In Europe on a year's leave of absence.

Miss SARAH E. McILWAINE,
(Peabody Conservatory, Burmeister),
Piano and Musical History.

Miss MAMIE E. GEARY,
(Boston),
Violin.

Mr. W. F. ALLEN,
(Boston),
Banjo, Guitar and Mandolin.

Miss HENRIETTA WESSEL,
Harp.

— 38 —

In 1871, the Methodist Episcopal Church, South, rallied support to establish a school for the preparation of Methodist Episcopal ministers. After attempting to raise funds for the school, in 1873, Bishop Holland Nimmons McTyeire's relationship with Cornelius Vanderbilt of New York led to the establishment of an endowment fund for the land and construction costs for Vanderbilt University. (Both, NPL.)

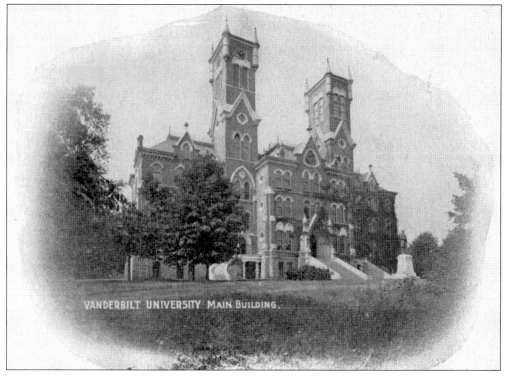

VANDERBILT UNIVERSITY MAIN BUILDING.

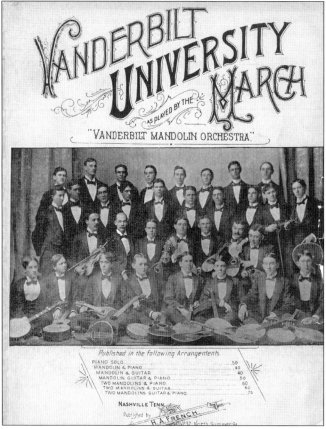

In addition to further advancing Nashville's foundation as a city of higher education, the musical activities of Vanderbilt University's Glee Club and Mandolin Club added to the musical life of Nashville in the 1880s and 1890s. Through the growing number of schools of higher education, as well as advancements in public school music education, particularly through the leadership of John E. Bailey, a foundation was laid for music instruction at all levels in Nashville. (Both, NPL.)

By 1892, the Nashville Conservatory of Music was established with 25 students enrolled under the leadership of Dr. August Schemmel (right). Schemmel came to Nashville from Berlin, where he had served on the faculty of the Royal Academy. He had various musical posts in Nashville, including serving on the teaching faculty of the Ward Seminary Conservatory of Music. The conservatory was housed at 331–333 North Summer Street. Xaver Scharwenka was the vice president of the conservatory. Scharwenka had founded his own conservatories in Berlin and New York before coming to Nashville. German immigrant Emile L. Winkler, born in Leipzig, took charge of the conservatory's piano department in 1897, and Ivo C. Miller was head of the violin department. Chevalier Giuseppe Ferrata was listed as part of the staff. This organization later merged with the University of Nashville as a college within the university, and late into the 19th century, German musical leadership was still evident in the school's curriculum. The 1897 University of Nashville catalogue stated that "the method of the College is that of Berlin and Leipzig, and the instructors are thoroughly conversant with that system." In 1896, the Tennessee Academy of Music was founded by German immigrant Franz J. Strahm. By the close of the decade, there were 60 music teachers listed in Nashville teaching privately or in one of the many educational institutions. (Both, NPL.)

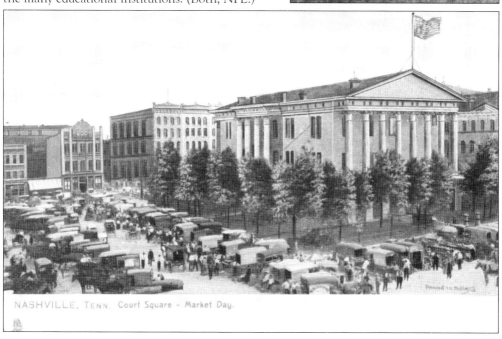

NASHVILLE, TENN. Court Square - Market Day.

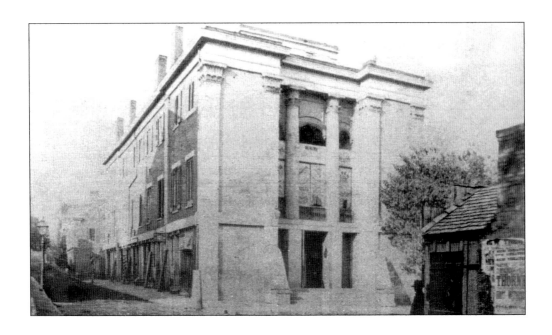

By 1880, the population of Nashville had grown to 43,350. The appetite for musical entertainment was met with added performance venues in the late 1860s. New venues included the Adelphi Theatre, the New Theatre, and the Masonic Hall. The Adelphi Theatre was designed by architect Adolphus Heiman and was located on the west side of North Cherry Street near Cedar Street. (Both, NPL.)

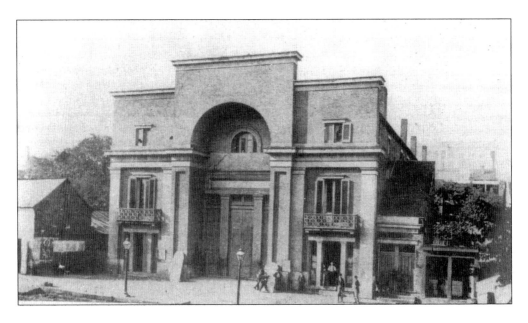

Seven

Private and Denominational Publishers Proliferate

Printing and publishing emerged in Tennessee during the last decade of the 18th century. In the early print publications, each page was set by hand. When a form was ready, each sheet had to be printed by hand, first on one side and then on the other. The type was then distributed, and the pages of another form set and printed. The ink had to be mixed and spread over the type with leather daubers. The paper was brought in from the East by horse or wagon or boat, and the cost was high. The binding was done entirely by hand. There was only one press, and the staff usually consisted of two men and a boy.

In 1798, Tennessee governor William Blount wrote to a man named Robertson in Nashville stating he "was glad to hear you are about to get a paper published in Nashville and that as the publisher is to come from Kentucky there is a well founded hope that he is not a ministerial printer." Benjamin J. Bradford appears as editor and publisher of the *Kentucky Journal* at Frankfort in 1795. In January 1800, Bradford started the *Tennessee Gazette* in Nashville.

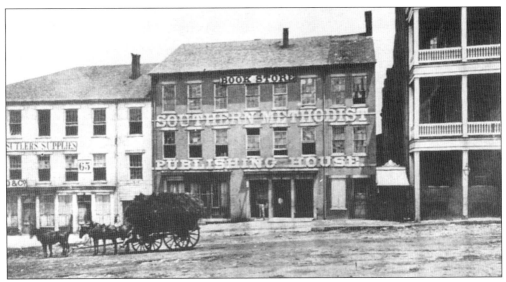

More printers followed Benjamin J. Bradford to Tennessee, as pioneers from Virginia and Kentucky sought better opportunities for publishing. In spite of Gov. William Blount's concerns regarding ministerial publishers, Nashville's reputation as a religious publishing center took hold in the 1830s and received a major boost in 1854 when the Methodist Episcopal Church, South, voted to establish a publishing and printing house in Nashville. This publishing enterprise was named the Southern Methodist Publishing House. (NPL.)

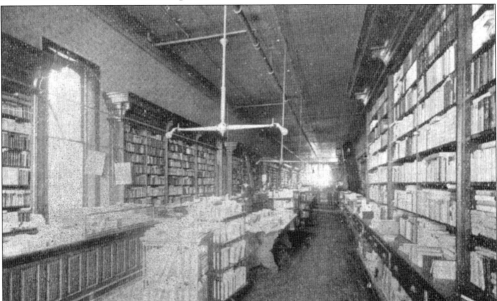

Louisville and Memphis had been the contenders for a publishing center before the Methodist Church's general conference in Atlanta that year, but the decision was made that Louisville was too close to the border to be considered a real Southern community, and Memphis was a "river town," which ruled it out. Nashville was already a religious publishing center and had been for 20 years. The *Western Methodist* was published there, as were the *Christian Advocate* and the various periodicals that succeeded it. Further, a Methodist bookstore had existed in Nashville since 1847, selling "a full and general assortment" of the church's books. (NPL.)

The Southern Methodist Publishing House became one of the largest publishing operations in the South. It was used during the Civil War by Federal troops as a military printing office. The original building was an old sugar warehouse that stood at the northeast corner of the public square. This publishing house was created to publish church periodicals, pamphlets, and books, and did its own printing as well. It was replaced when it burned in 1872 but remained in the same location until 1906, when it moved to the corner of Broadway and Ninth Avenue. (NPL.)

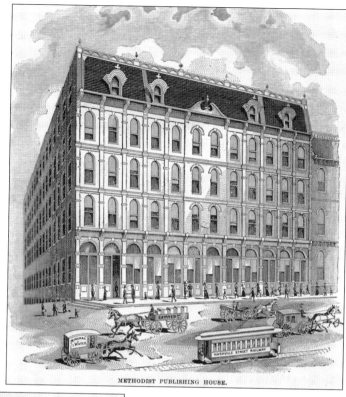

METHODIST PUBLISHING HOUSE.

Irish immigrant John McLeod Keating came to Nashville in 1855 to run the Southern Methodist Publishing House. Keating was born June 12, 1830, in King's County, Ireland, of Scotch-Irish parents. Educated in Scotland until his ninth year, he completed his schooling in Dublin, Ireland. At 13 he was apprenticed to the printer's trade, and at 18 he was foreman of the printing plant of the *Dublin World* and a prominent member of the Young Ireland Club. After the revolution staged by that organization in 1848, he fled to America, settled in New York, and again became foreman of a newspaper plant. In 1854, Keating left New York and sailed to New Orleans, then to Baton Rouge, and then to Nashville, where he was made foreman of the composing room of the Southern Methodist Publishing House.

A scandal, rare in denominational publishing, broke in 1898 when the New York *Herald* charged that a Methodist minister in Nashville had been paid as a lobbyist to get an appropriation bill passed in Congress. The bill would give the Methodist book concern's Nashville unit $288,000 as recompense for damages alleged to have been suffered from the occupation and use of its establishment by Federal troops during the Civil War. It was fought in both houses of Congress and only passed when the united influence of the Methodist Church was brought to bear. Bishops of the church indignantly denied the *Herald*'s story and offered to return the money if it could be proved true. No one came forward with the proof. (RS.)

In 1855, J. R. Graves established the Southwestern Publishing House, bringing both magazines and books together under one publishing roof. The *Tennessee Baptist* was its most popular publication. Southwestern was located at 59 North Market Street. On August 12, 1855, James A. McClure became a partner with Nashville music merchant E. Morton, forming the McClure sheet music publishing company. McClure's firm dealt in sheet music, musical instruments, and accessories, and established a music-publishing firm that gained national attention. The McClure Company advertised regularly, with the following appearing in the March 29, 1867, *Republican Banner*: "McClure has just received a Steinway Grande, which is unsurpassed for richness, power, modulation, and touch. It was ordered for one of our leading citizens, but is on exhibition at McClure's music room, on Union Street. Lovers of 'the art' will do well to pay an early visit. Such an instrument is not to be seen every day, even in the capitals (sic) of song, and seldom or never in Nashville."

THE

TENNESSEE FORM BOOK.

LEGAL FORMS OR PRECEDENTS ESPE-
CIALLY PREPARED FOR USE
IN TENNESSEE;

TOGETHER WITH

REMARKS AND SUGGESTIONS.

BY JOHN ALEX. CAMPBELL.

———

THIRD EDITION.

———

NASHVILLE. TENN.:
MARSHALL & BRUCE, PUBLISHERS.
1886.

Another printing enterprise started in Nashville in 1865. James H. Bruce was the organizer, and Andrew Marshall was his associate. Under the firm name of Marshall and Bruce, the company bought a building on Main Street. This company remained a printing house into the 20th century. Among the publications of Marshall and Bruce were the legal books for the state of Tennessee. (Below, NPL.)

The Marshall and Bruce building was 70 feet tall and ran back 170 feet to an alley. In the rear was the pressroom where eight cylinder presses were operated. Major contracts for the company during this time included the publications of the Baptist Sunday School Board, the *Code of Tennessee*, the *Digest of Alabama Reports*, and the *Gray & Dudley Hardware Co. Catalogue.*

The National Baptist Publishing Board, established in Nashville in 1896 by Richard Boyd, is the country's oldest African American–owned publishing business. David Kaser's directory of book and printing industries in Nashville before the war lists nine publishers that appeared to be primarily devoted to book publishing. In addition to the two religious houses, there were Graves and Marks; Hunt, Tardiff and Company; J. A. McClure Music Publisher; John S. Simpson; Joseph Norvell; Tunstant and Norvell; and Hall and Fitzgerald. (Above, TSA.)

As publishing and music publishing flourished in Nashville, the language used for music continued to be dominated by the influence of European immigrants. Germans and Italians shaped the language and way Americans think of music. In England, the terms minim, crochet, quaver, and semi-quaver were the language of note values, then and now. Musicians in the United States use the terms quarter note, half note, eighth note, sixteenth note, and so on to describe the length a note is held. Few realize that this is German precision and German thinking at work, as well as the language adopted for talking about music in the United States. (Left, NPL.)

Eight

In One Era and Out the Other

The line between religious and secular music continued to blur in the last decades of the 19th century. By 1902, Nashville's Union Gospel Tabernacle converted to become the Ryman Auditorium, a venue for music performances of all descriptions. The second professional musician's union formed in Nashville, and businesses as well as entrepreneurs became interested in the commercial value of Tennessee's music.

The National Life and Accident Insurance Company had begun operation in Nashville and would later start radio station WSM as a new advertising and public relations outlet. These convergences led to the broadcast of the Grand Ole Opry from the Ryman Auditorium and the resulting categorization of an old musical style reborn on WSM radio as country music.

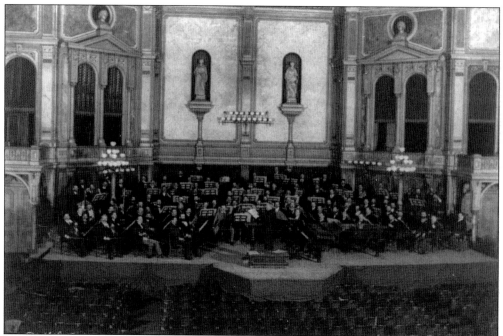

After the Civil War, new performing venues were established in Nashville. These included the New Nashville Theatre in Odd Fellows Hall, the Concert Hall, and the Masonic Hall. Itinerant concert artists—such as the Pozanski brothers, Ole Bull, and Anton Rubinstein, as well as opera troupes such as Holman's English Opera Company and the Signor Lotti Grand Opera Company, and touring ensembles such as Boston's Mendelssohn Quintette Club and Theodore Thomas' Orchestra (above)—frequented Nashville at closer and closer intervals. German musicians resumed their influence on classical music as evidenced by a March 29, 1867, newspaper announcement of a benefit concert to be given at the New Theatre by "the German Citizens of Nashville." (Above, LOC; below, TSA.)

The German Turn Verein was established on October 24, 1865, giving its membership an opportunity to participate in dramatic, musical, and literary activities. The Turn Verein met at Turner's Hall at the corner of North Market and Gay Streets. In addition to the Turn Verein, other social groups formed to support the social and benevolent needs of Nashville's German citizens. These groups included Die Deutsche Unterstutzunge-Gesellschaft (the German Relief Society); the Aurora Lodge, No. 105 of the Independent Order of the Odd Fellows; the German Order of the Harugari; the Germania Lodge of the Masons; Familienbund; the German-American Centennial Association; the German and American Society; the German Immigration Society; the Zweidollarverein; and a Mannerchor, a singing society for men. (Above, MPL.)

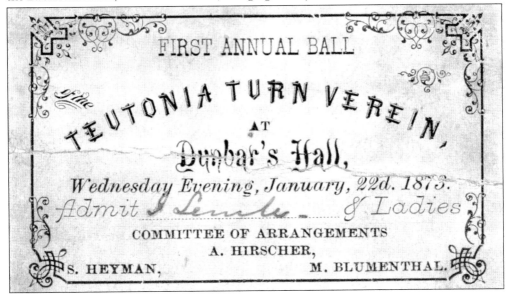

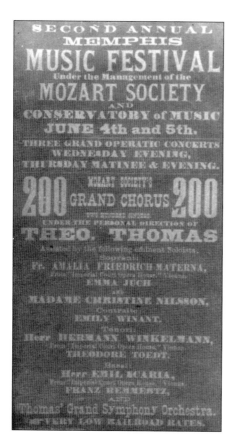

Theodore Thomas became a well known and influential conductor in the second half of the 19th century. His orchestral concert tours were popular on the touring circuit, and Thomas made several appearances in Nashville. His orchestra boasted 60 distinguished performers pronounced by the entire press as the largest and most perfect Concert Troupe that has ever undertaken a tour either in this country or in Europe. Thomas, born in Germany, was a major influence in music appreciation and education throughout the United States because of these concert tours.

The Memphis Opera Company under the direction of German immigrant Christopher Philip Winkler performed *Fra Diavolo* at the Grand Opera House on May 8, 1878. Winkler was a prolific composer, conductor, and music teacher that had come first to Jackson, Tennessee, where he taught at the Female College (Lambuth University). He moved to Memphis in 1854, working throughout his life as music director at St. Peter's Catholic Church. At the end of his career he was called the "Dean of Memphis Musicians."

The years between 1875 and 1900 witnessed the doubling of Nashville's population, as well as the coming of age of the city musically. These were years of civic growth and optimism as the city expanded. By 1910, the population of Nashville swelled to 110,364, making Nashville the sixth largest city in the South. Bridges, roads, and railways contributed to Nashville's expansion. New performance venues included the Vendome Theatre, Watkins Hall, the New Masonic Theater, the Grand Opera House, the Broad Street Amusement Hall, and the New Park Theater. Of these theaters, the Vendome Theater (right) that opened on Church Street between Sixth and Seventh Avenues on October 3, 1887, was the crowning jewel. (NPL.)

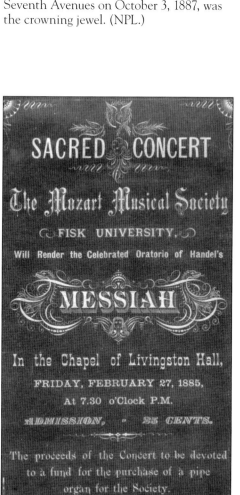

The Fisk University Singers performed William B. Bradbury's *Esther: The Beautiful Queen* at the Masonic Hall on March 9 and 10, 1871, and in February 1872, the Nashville Choral Society presented Handel's *Messiah*. Choral organizations, church music programs, and private schools of music, such as the new Southern Conservatory of Music, continued to present concerts. The repertoire consisted of works by Haydn, Mozart, Handel, and Mendelssohn, and in the area of opera, German and Italian compositions dominated. (NPL.)

The first production in the Vendome Theater was *Il Trovatore*, performed by Emma Abbott and the English Grand Opera Company. According to the Nashville *Daily American*, "Never has Nashville witnessed the presentation of *Il Trovatore* with such éclat and effect as it was given by this superb company of artists." On March 27, 1890, violinist Pablo de Sarasate and pianist Eugene D'Albert performed at the Vendome. The concert was described in the *Daily American* as an "uncompromising presentation of pure art" and one of the finest to have appeared in Nashville to that time. Other concerts at the Vendome included pianist Xaver Scharwenka, the Carleton Opera Company, the Emma Juch Grand English Opera Company, and a performance of Gilbert and Sullivan's *H.M.S Pinafore* by local performers. On January 8, 1894, Adelina Patti (pictured left) returned to Nashville for a performance at the Vendome, and on April 17, 1895, John Philip Sousa's Band (pictured below) returned to Nashville. (Both, LOC.)

The Philharmonic Society formed in 1892 to sponsor concerts specifically for the Vendome Theater. These concerts included a touring performance by New York's Metropolitan Opera Company. In 1901, the turnout for another touring opera company exceeded the seating capacity of the Vendome, forcing the production to move to the Union Gospel Tabernacle (pictured below). The ongoing performance of opera in this venue would lead to the famous "Opry" nickname in the later transformation to the world-renowned Grand Ole Opry. (Right, TSA; below, NPL.)

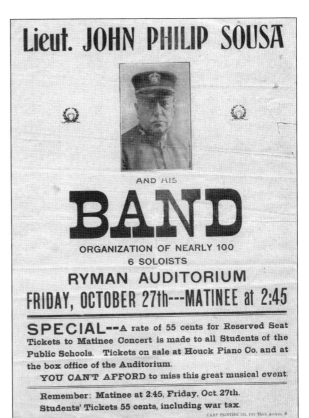

Lieut. JOHN PHILIP SOUSA

AND HIS

BAND

ORGANIZATION OF NEARLY 100
6 SOLOISTS

RYMAN AUDITORIUM
FRIDAY, OCTOBER 27th---MATINEE at 2:45

SPECIAL--A rate of 55 cents for Reserved Seat Tickets to Matinee Concert is made to all Students of the Public Schools. Tickets on sale at Houck Piano Co. and at the box office of the Auditorium.

YOU CAN'T AFFORD to miss this great musical event.

Remember: Matinee at 2:45, Friday, Oct. 27th.
Students' Tickets 55 cents, including war tax.

CARP PRINTING CO. 233 Third Avenue, N

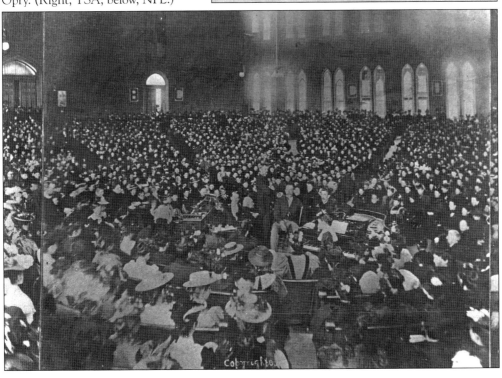

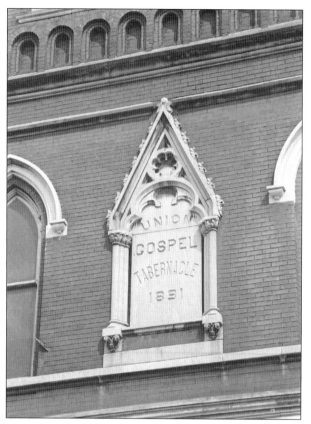

Starting construction in 1888, the Union Gospel Tabernacle was completed in 1892 at a cost of $100,000. The building resulted from the financial development work of Rev. Sam Jones and steamboat captain Tom Ryman. Seating capacity was expanded in 1897 as a result of the addition of a balcony with funds given by the Confederate Veterans Association. Further expansion took place in 1904 when the stage was enlarged so that opera productions could be staged. When Tom Ryman died in 1904, Reverend Jones suggested that the building be renamed to honor Ryman, resulting in the name Ryman Auditorium. It continued to host concerts and full operatic productions. When Ryman Auditorium later became the home of National Life's and WSM's Grand Ole Opry, the provincial nickname had solid historic precedent. (Above, LOC; below, TSA.)

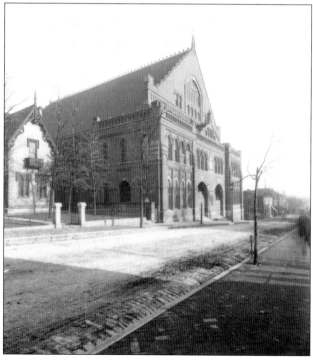

Designed by Nashville architect Hugh Thompson in a Victorian Gothic style, the Ryman Auditorium provided a contrast to the honky-tonk bars that lined adjoining Broadway such as Tootsie's Orchid Lounge. "Opry" was not the only play on words that came to identify the auditorium. It has also been called the "mother church" of country music, a play on its origins as the Union Gospel Tabernacle. (NPL)

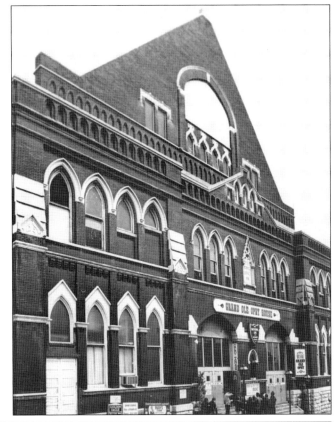

Minstrel shows remained popular in Nashville into the last decades of the 19th century, but by then, vaudeville troupes had joined the popular entertainment circuit. Traveling opera troupes continued to be successful. Alice Raymond, "America's Greatest Lady Cornet Player," enjoyed a two-week run at the Glendale Park Music Hall in September 1888.

PSALMS AND HYMNS

ADAPTED TO

SOCIAL, PRIVATE,

AND

PUBLIC WORSHIP,

IN THE

CUMBERLAND PRESBYTERIAN CHURCH

'AUTHORIZED BY THE GENERAL ASSEMBLY, AT HER
SESSION IN HUNTSVILLE, ALABAMA, A. D. 1858.'

NASHVILLE, TENN.:
C. P. BOARD OF PUBLICATION.
1870.

Printing and publishing in Nashville grew significantly after the Civil War. The Brandon Printing Company was housed in a six-story building on Market Street. Additional printing firms included Marshall and Bruce, Foster and Webb, Hasslock and Ambrose, Albert B. Tavel, and the Davis Printing Company. Joining the list of religious and denominational publishing companies, the Cumberland Presbyterian Publishing House was built in 1890. Religious magazines and periodicals poured out of Nashville under the titles of the *Free Baptist Banner, Advocate Lesson Paper, Illustrated Lesson Paper, Little Jewel, Rays of Light, Baptist and Reflector,* and *Christian Advocate.* (Left, RS; below, NPL.)

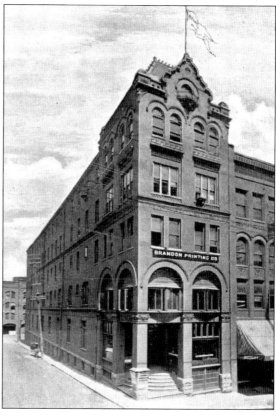

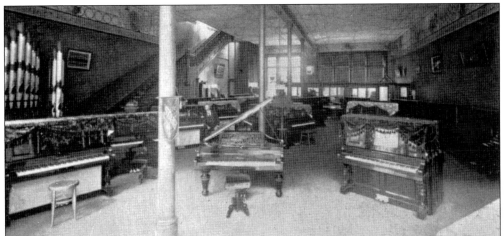

Included in the blossoming group of music publishers was the Jesse French firm, established in 1872 when French became a partner in the R. Dorman and Company music dealership. In 1878, French established his own company, the Jesse French Piano and Organ Company, which dealt in pianos, organs, and printed music. The company was first located at 85 Church Street and, in 1887, had 75 employees, 35 of which were traveling salesmen. The company had branches in St. Louis, Missouri; Little Rock, Arkansas; Memphis, Tennessee; and Birmingham, Alabama. Henry A. French was a clerk for the company. Later the company relocated to a five-story building at 240–242 North Summer Street. William Waller gives a description of the French building: "It is all iron, steel and plate glass, and the largest sheets of plate glass yet put up in Nashville are in this front. This building is five stories high, and has a basement; its floors have an area of 15,750 square feet; it is finished in hard woods; has elevators and all modern improvements." (All, NPL.)

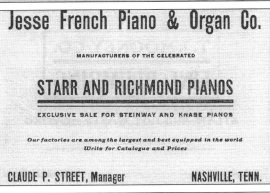

William Waller called the French building "the handsomest front in Nashville." The French company carried pianos from Steinway, Chickering, Weber, Chase, Haines Brothers, Grovesteen and Fuller, Story and Clark, Mason and Hamlin, Packard, New England, and Hardman, and had a piano stamped with his own "Jesse French" label. He carried organs from Estey, New Haven, and other companies. According to advertisements, the French company boasted the lowest prices in town. Pianos sold for $200, and organs sold for $65. In addition to the Jesse French dealership, McClure's and Dorman's sold sheet music and pianos.

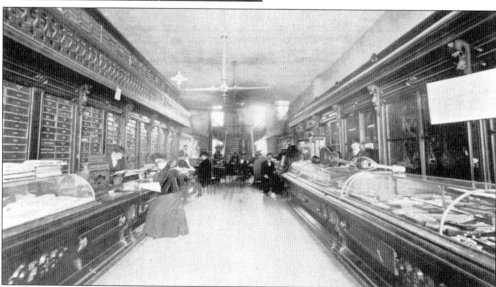

Henry A. French, a clerk at the Jesse French company, launched his own music company, H. A. French, in 1883 that dealt in sheet music, musical books, and instruments, as well as their self-proclaimed advertisement of "everything in the musical line." H. A. French became a well-known music publisher in Nashville, offering more than 12,000 of his own publications. (TSA.)

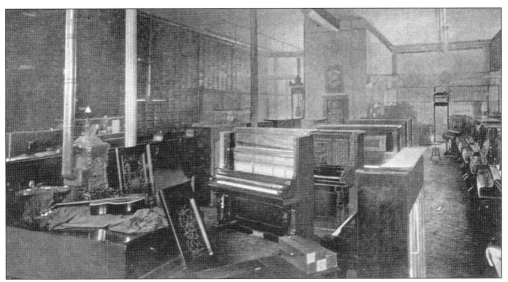

Across the country, German piano makers were coming to the new land of opportunity. Most of the names of these technicians have been forgotten but not the important one—Henry E. Steinway. Steinway and his sons established a piano empire in the United States that became the standard of excellence for American pianos. Steinway, originally from Braunschweig, Germany, arrived in New York in 1850. Three years later, the firm of Steinway and Sons was founded. By 1869, Steinway and Sons was the foremost producer of pianos in the United States. When Nashville's WSM radio began operations in 1925, the luxuriously appointed studio was furnished with wingback chairs, an ornate desk, a crystal chandelier, and an ebony Steinway grand piano. (NPL.)

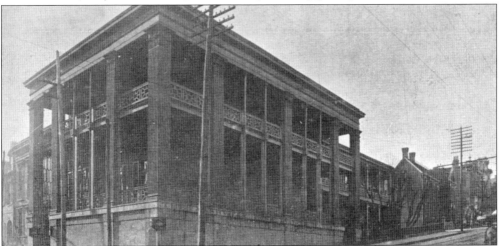

Nashville hosted its annual May Musical Festival, which reflected European festival practice. The festival took place in the Union Gospel Tabernacle. In 1892, the headline attraction was Theodore Thomas and the Chicago Symphony Orchestra. The festival featured a chorus of 500 singers along with the orchestra and drew a crowd of 2,400 people. The program included Saint-Saëns' *Danse Macabre*, Grieg's *Peer Gynt Suite*, Wagner's Overture to *The Flying Dutchman*, Handel's "Hallelujah" chorus, Haydn's "The Heaven's Are Telling," and additional works by Wagner, Brahms, and Mendelssohn. On November 4, 1892, the 50-member chorus of the Philharmonic Society under the direction of Nashville Conservatory (pictured) professor August Schemmel presented a Mendelssohn Memorial Concert at Watkins Hall. (NPL.)

Terms related to piano manufacturing entered general language practice as evidenced by phrases such as "a sounding board" and "soft pedaling." Of the two leading manufacturers of pianos in the United States, the English-inspired Chickering piano firm was solidly beat out by the German-inspired Steinway technology. (Both, CPM.)

The 1894 May Music Festival featured the Walter Damrosch Orchestra and the Nashville Choral Union, the sponsor of the event. On October 24, 1894, John Philip Sousa's Peerless Band performed at the Union Gospel Tabernacle.

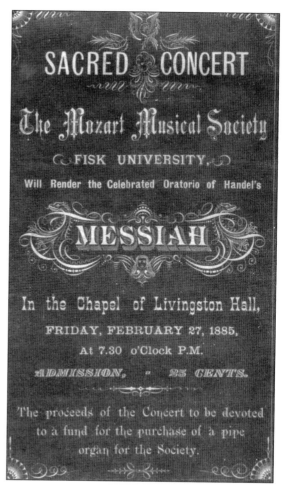

SACRED CONCERT

The Mozart Musical Society

FISK UNIVERSITY.

Will Render the Celebrated Oratorio of Handel's

MESSIAH

In the Chapel of Livingston Hall,

FRIDAY, FEBRUARY 27, 1885,

At 7.30 o'Clock P.M.

ADMISSION, - 25 CENTS.

The proceeds of the Concert to be devoted to a fund for the purchase of a pipe organ for the Society.

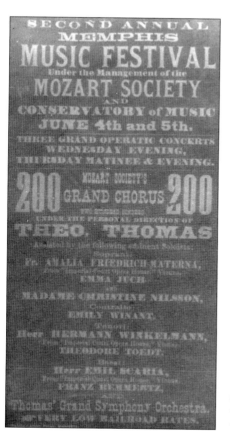

SECOND ANNUAL
MEMPHIS
MUSIC FESTIVAL
Under the Management of the
MOZART SOCIETY
AND
CONSERVATORY of MUSIC
JUNE 4th and 5th.
THREE GRAND OPERATIC CONCERTS
WEDNESDAY EVENING,
THURSDAY MATINEE & EVENING.
200 MOZART SOCIETY'S GRAND CHORUS 200
UNDER THE PERSONAL DIRECTION OF
THEO. THOMAS
Assisted by the following eminent Soloists,
Fr. AMALIA FRIEDRICH MATERNA,
EMMA JUCH
MADAME CHRISTINE NILSSON,
EMILY WINANT,
Herr HERMANN WINKELMANN,
THEODORE TOEDT
Herr EMIL SCARIA,
PRINZ REMMERTZ
Thomas' Grand Symphony Orchestra.

Organizations such as Fisk University's Mozart Society, the Philharmonic Society, and the Schubert Symphony Club continued to demonstrate a German influence in the selection of concert repertoire.

On October 10, 1895, a public referendum approved the appropriation of $100,000 to support the Tennessee Centennial and International Exposition. The planning committee decided that musical variety would be a hallmark of what was offered throughout the exposition. This ignited a series of concerts and events in support of the exposition. Among the leaders of the effort was Kate Kirkman, president of the Woman's Board for the exposition. (Above, MPL; below, TSA.)

The Tennessee Centennial and International Exposition opened on May 1, 1897, and ran for six months. The standing ensemble for the exposition was Gustav Fischer's Centennial Orchestra. At the opening of the event, the Bellstedt-Ballenberg Band from Cincinnati, Ohio, was the featured ensemble, demonstrating a strong dependency upon German musicians. This band was a favorite throughout the exposition. Composer and pianist Edward McDowell (right) made his premiere with the Boston Orchestra at the Tennessee exposition. (LOC.)

THE GREAT CENTENNIAL ORGAN.

A pipe organ was built and installed in the exposition auditorium, and organ recitals were occasionally performed as a feature of the exposition. The organ was built by the Hook and Hastings Organ Company and was later acquired by Fisk University. Concerts and recitals were performed in the auditorium by students and members of the faculty of the Nashville Conservatory of Music throughout June and July 1897. (NPL.)

An extraordinary architectural highlight of the Tennessee Centennial and International Exposition was the building of a full-scale replica of the Greek Parthenon. The building was composed of temporary materials, and designed by Nashville architect Col. W. C. Smith and sculptor George J. Zolnay. It was later replaced with permanent materials. The Parthenon reflected the city's aspirations and underscored its image as the "Athens of the South." (Above, LOC; below, TSA.)

The auditorium was built "in loving remembrance by all who are fond of the highest music." The auditorium featured daily performances, including the best bands and orchestras in the country. The Tennessee Centennial and International Exposition's opening events were held here, and every day featured concerts in this location. (Both, NPL.)

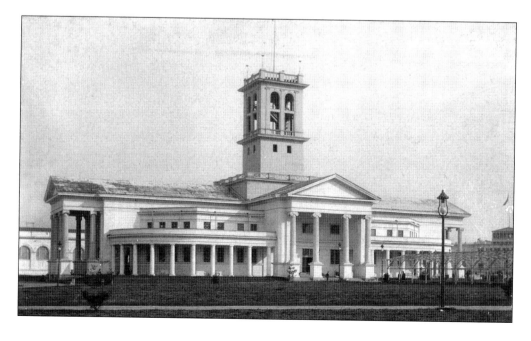

The O. K. Houck Company of Memphis sponsored a $100 prize and publication for the best piano composition in the form of a march for the Tennessee Centennial and International Exposition. The winning march was published by Houck (pictured left) as the "Tennessee Centennial Prize March." Exactly 288 compositions were submitted for the contest, and the winning piece was by Maurice Bernhardt, a Memphis music teacher. The following description was printed on the published composition: "On October 1, 1896, we offered a price of $100 each for the best original composition for the piano in the form of a march, to be published as the 'Tennessee Centennial Prize March.' This offer was published in several thousand newspapers, and resulted in our receiving 288 manuscripts from 33 states. The contest closed January 1st, 1897, and after an impartial examination of the manuscripts, without knowing composer's names, the three judges, H. A. Frank, of Nashville, Tenn., Jno. W. Keyes, of Louisville, KY;, and F. E. Miles of Memphis, Tenn., unanimously awarded the prize to manuscript No. 168, composed by Maurice Bernhardt, of Memphis, Tenn. This march was first played in public by Sousa's Peerless Band at Grand Opera House, Memphis, on January 20, 1897." (Both, MPL.)

The highest profile musical artist for the exposition was Victor Herbert (pictured above) and his 22nd Regiment Band from New York. Herbert and his band were in residence throughout August and the first week of September 1897. The daily performances were enthusiastically attended, drawing thousands to the event. In the end, the cost of the exposition was $1 million, with more than $90,000 of that amount spent on music and entertainment. (LOC.)

Women's musical organizations were a growing interest in the 1890s. In Nashville, the Wednesday Morning Musicale was such an organization. Founded on February 10, 1892, this women's group held biweekly meetings in the homes of its membership and sponsored concerts and recitals in Nashville in the years that followed. In October 1898, the society split, forming the Philharmonic Society.

Two of the most popular Tin Pan Alley songwriters in the 1890s were Harry Braisted and Stanley Carter. Their hit songs included "You're Not the Only Pebble on the Beach" and, in 1899, "The Girl I Loved in Sunny Tennessee." This song became a vaudeville favorite, advancing Tennessee stereotypes. It was also a hit with early country recording artists such as North Carolina singer Charlie Poole, Harvey Irwin, Ernest Stoneman, Fiddlin' John Carson, the McCravy Brothers, and the Dixon Brothers. Tennessee's relationship to early country singers was firmly established with this hit: "On one morning bright and clear to my old home I drew near, / Just a village down in sunny Tennessee, / I was speeding on a train that would take me back again, / To the girl I loved in sunny Tennessee." (CPM.)

Music as well as education entrepreneurship continued in Nashville into the 20th century. Composer Henry Weber's daughter Mary, along with her husband Frederick Emerson Farrar (pictured), founded the Farrar School of Voice and Piano in 1910. Frederick arrived in Nashville in 1891 and taught at the Ward Seminary for Young Ladies. A native of Boston, Farrar received his musical training in Germany and Italy. (TSA.)

Nashville became the second city in the country to organize a musician's union in 1902. The Nashville Association of Musicians, Local No. 257 of the American Federation of Musicians, was chartered in December 1902 with members Charles F. Davis, C. J. Schubert, Will R. Martin, Nick Melfi, Rudolph Moehl, Charles F. Hefferman, John Keech, and Jesse Martin. Joe Miles was the union's first president. The first musician's union established in the United States was formed in Memphis, Tennessee, on December 6, 1873. (NPL.)

From its earliest days, Tennessee has been a state with three separate regions as well as musical "states of mind." In 1835, it established a supreme court with three judges, one each from East, Middle, and West Tennessee. The state flag displays three stars—one for each of these three regions. The recently minted Tennessee quarter has a fiddle symbolizing East Tennessee's bluegrass music, a guitar symbolizing Middle Tennessee's country music, and a trumpet symbolizing the blues of West Tennessee. The backstory for each of these symbols is a story of the convergence of cultures from the three regions of Tennessee.

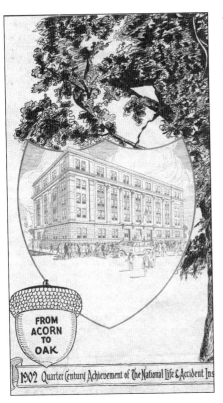

FROM
ACORN
TO
OAK.

1902 Quarter Century Achievement of The National Life & Accident Ins

The National Life and Accident Insurance Company began in 1900 as the National Sick and Accident Association. It later reorganized and adopted the National Life name. Known for its creative marketing development, National Life began WSM radio in 1923 as a result of the work of Edwin Craig, going on the air for the first time in 1925. Being one of the earliest stations in radio broadcasting, the call sign was only three letters, WSM, based on the company's insurance motto "We Shield Millions." The station began by broadcasting inside the National Life office building in downtown Nashville. In October 1925, the popular and historic Grand Ole Opry show began broadcasting on WSM radio, making Tennessee folk music a mainstream form of musical entertainment worldwide. In the early years of the 20th century, Nashville gave back to the world what the world had contributed to Nashville in its convergence of immigrants, customs, and music. This music was a result of the union of musical styles from people of various countries that charted new courses, as well as new sounds in the New World. These convergences came together in a state and in a city that appreciated music and entertainment at an extraordinary, passionate level. (Left, NPL; below, TSA.)

WSM—AMERICA'S TALLEST RADIO TOWER, 878 FEET, NASHVILLE, TENN.

323 FEET HIGHER THAN THE WASHINGTON MONUMENT

Nashville's music story has a unique twist. In Nashville, music and entertainment united with a publishing industry, a demonstrated passion for education and religion, and media technologies that began as early as the 1850s to set off a musical explosion that catapulted music from Nashville to the world. This foundation gave WSM announcer David Cobb the courage in 1950 to proclaim Nashville as "Music City USA." Nashville took the folk music and native influences that had converged in Tennessee from other parts of the world and returned that music to the world. (Both, TSA.)

Bibliography

Primary Sources

Allen, William Francis. *Slave Songs of the United States*, 1867, Part III, Inland Slave States, including Tennessee, Arkansas, and the Mississippi River (103–111).

Commercial Appeal, January 1, 1940. "Keating and Gallaway, Famed Editors of The Appeal, Defied Carpetbaggers and The Yellow Fever Alike."

Official Guide to Tennessee Centennial and City of Nashville. Nashville, TN: 1896.

Rose, Kenneth Daniel. *Pioneer Nashville: Its Songs and Tunes: 1780–1860, Transition, and Fruition.* Nashville, TN: self-published memoirs.

Kenneth Daniel Rose Papers, Accession Nos. 429 and 118, II G 2, Tennessee State Archives, Nashville, TN.

Sharp, Cecil J. *American-English Folk-Ballads.* New York: G. Schirmer, 1918.

Srygley, F. D. *Seventy Years in Dixie.* Nashville, TN: Gospel Advocate Publishing Company, 1891.

Secondary Sources

Connelly, John Lawrence. *North Nashville and Germantown*. Nashville, TN: The North High Association, 1982.

Crain, Charles Robert. *Music Performance and Pedagogy in Nashville, Tennessee, 1818–1900*. Unpublished Ph.D. dissertation, Nashville, TN: George Peabody College for Teachers, 1975.

Doyle, Don H. *New Men, New Cities, New South: Atlanta, Nashville, Charleston, Mobile, 1860–1910*. Chapel Hill, NC: The University of North Carolina Press, 1990.

Egerton, John. *Nashville: The Faces of Two Centuries: 1780–1980* Nashville, TN: Plusmedia Inc., 1979.

Hahn, Phyllis Elizabeth. *German Settlers in Nashville, Tennessee*. Unpublished master's thesis, Nashville, TN: Vanderbilt University, 1935.

Havighurst, Craig. *Air Castle of the South: WSM and the Making of Music City*. Urbana, IL: University of Illinois Press, 2007.

Hitchcock, H. Wiley. *Music in the United States*. Englewood Cliffs, NJ: Prentice-Hall, 1974.

Holden, Alyce K. *Secular Music in Nashville: 1800–1900*. Unpublished master's thesis, Nashville, TN: Fisk University, 1940.

Hoobler, James A. *Cities Under the Gun: Images of Occupied Nashville and Chattanooga*. Nashville, TN: Rutledge Hill Press, 1986.

Hoobler, James A. *Distinctive Women of Tennessee*. Nashville, TN: An Exhibition by the Tennessee Historical Society, 1985.

Macpherson, Joseph Tant, Jr. *Nashville's German Element—1850–1870*. Unpublished master's thesis, Nashville, TN: Vanderbilt University, 1957.

Music, David W., ed. *A Selection of Shape-Note Folk Hymns From Southern United States Tune Books, 1816–61*. Middleton, WI: A-R Editions, Inc., 2005.

Nicholson, William B. *Profiles of Early Tennessee Leaders: 1780–1861*. Nashville, TN: self-published with grant from Metropolitan Historical Commission, 1977.

Rose, Kenneth. "A Nashville Musical Decade, 1830–1840." *Tennessee Historical Quarterly*, 216–231.

Sharp, Tim. *Memphis Music Before the Blues*. Charleston, SC: Arcadia Publishing, 2007.

Tebbel, John. *A History of Book Publishing in the United States*, vol. 2, *Methodist Publishing* (New York and London: R. R. Bowker, 1972), 552–53.

Tennessee Printers, 1791–1945: A Review of Printing History from Roulstone's first Press to printers of the present by Joseph Hamblen Sears. Kingsport, TN: Privately Printed by the Kingsport Press, Inc.

Waller, William, ed. *Nashville in the 1890s*. Nashville, TN: Vanderbilt University Press, 1970.

Wolfe, Charles K., ed. *Folk Songs of Middle Tennessee: The George Boswell Collection*. Knoxville, TN: The University of Tennessee Press, 1997.

Wooldridge, John. *History of Nashville, Tennessee*. Nashville, TN: Publishing Company of the Methodist Episcopal Church, South, 1890.

Zimmerman, Peter Coats. *Tennessee Music: Its People and Places*. San Francisco, CA: Miller Freeman Books, 1998.

Index

ACROSS AMERICA, PEOPLE ARE DISCOVERING SOMETHING WONDERFUL. *THEIR HERITAGE.*

Arcadia Publishing is the leading local history publisher in the United States. With more than 4,000 titles in print and hundreds of new titles released every year, Arcadia has extensive specialized experience chronicling the history of communities and celebrating America's hidden stories, bringing to life the people, places, and events from the past. To discover the history of other communities across the nation, please visit:

www.arcadiapublishing.com

Customized search tools allow you to find regional history books about the town where you grew up, the cities where your friends and family live, the town where your parents met, or even that retirement spot you've been dreaming about.